SCHOOL OF ARCHITECTURE
MONTANA STATE UNIVERSITY

COLOR AND METHOD IN PAINTING

CREATIVE ARTS LIBRARY

Color and Method in Painting . . . by Ernest W. Watson

Outdoor Sketching by Ernest W. Watson

Pencil Drawing by Ernest W. Watson

Watercolor Demonstrated . . Edited by Watson & Kent

The Relief Print Edited by Watson & Kent

Type Specimens by William Longyear

Lumiprinting by Joseph di Gemma

Animal Drawing and Painting . . by W. J. Wilwerding

40 Illustrators and How They Work . by Ernest W. Watson

Other Titles in Preparation

COLOR
AND METHOD
IN PAINTING

As seen in the work of

12 American Painters

by

ERNEST W. WATSON

WATSON-GUPTILL

PUBLICATIONS, INC.

New York

DEDICATED
TO THE TWELVE
AMERICAN PAINTERS
REPRESENTED
IN THIS VOLUME

PREFACE

THE purposes and practices of the artist are deeply mysterious to his fellow men. In spite of all that has been written, very little is known of the painter's creative processes. These interviews with twelve of America's most distinguished painters were designed to broaden that knowledge as the author takes us into the artists' studios and demonstrates just what goes into the making of a picture.

Some chapters are concerned chiefly with the strictly creative phase — the birth of ideas and their development. This involves the artist's entire background of experience and training and the organization of his life to achieve his goal.

Other chapters emphasize the technical aspect of the artist's work; that is the craft of painting. Here the author has made a great contribution to a better understanding of the artist and his art. The student and fellow artist have a very practical interest in what they see as, through the eyes of the author, they look over the painter's shoulder. The layman also will find this excursion into the realm of paint and procedures a considerable factor in his better appreciation of the painter's problems and the pictures he paints.

The book is not a critical treatise in any sense. The author has no interest in classifying the painters with reference to schools, movements or trends. His object is rather to present a cross-section of varying painting philosophies and practices. He has sought diversity also in experience — the youngest painter is twenty-five, the oldest sixty-seven. Always he has endeavored to express the artist's ideas rather than his own.

In addition to the disclosure of important information about these twelve artists as individual painters, the book, we believe, gives a true picture of the American artist as a highly intelligent, well-organized and industrious member of society. He is as substantial a citizen as the banker and the lawyer. He may be as temperamental as the plumber. Like most Americans he loves his wife, adores his children and gives as little cause for scandal as the family doctor. All these factors are commonplace to those who have a wide acquaintance among painters. But too many people have focused their reading upon the sensational behavior of a few abnormal European artists who have been widely publicized.

The chapters originally appeared as feature articles in the magazine *American Artist*. Because of their value as permanent records of the painting methods of important contemporary artists the publishers have been repeatedly urged to print them in book form.

A word should be said here in appreciation of the generous cooperation of the artists who appear in the book. They willingly submitted to several interviews, and in many instances even set down their ideas and practices in writing so that they might be accurately quoted. They have read and approved all that has been written about them. We take this opportunity to thank them for making this book possible.

The Publishers

CONTENTS

COLOR PLATES

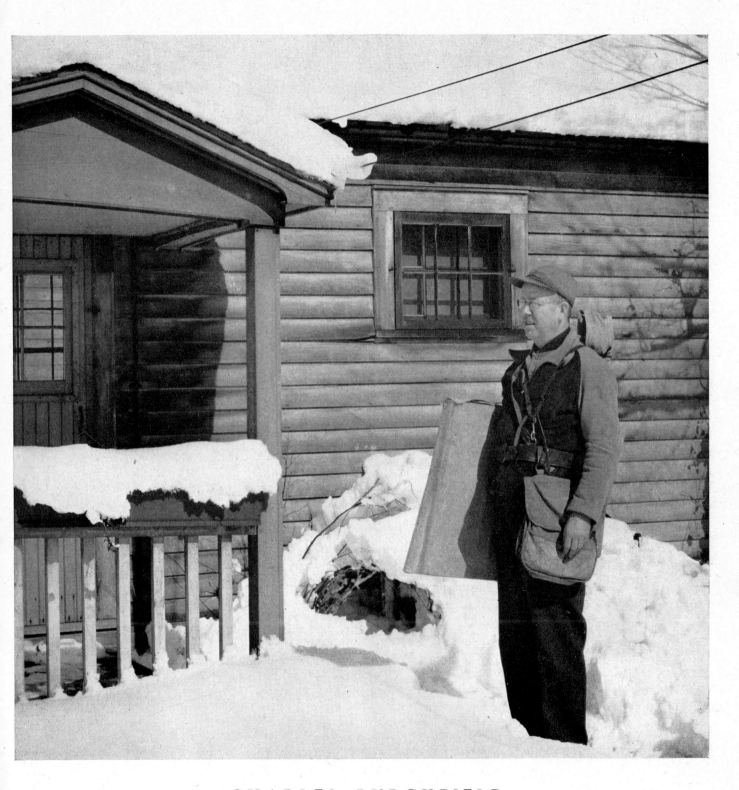

CHARLES BURCHFIELD

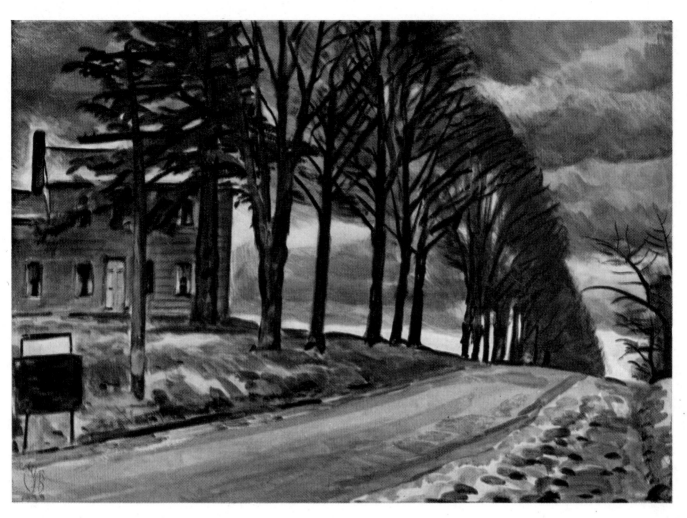

MARCH ROAD——WATERCOLOR BY CHARLES BURCHFIELD

Collection of Mrs. R. S. Maguire

Charles Burchfield

DURING the decade when Charles Burchfield's fame was in the making, he was raising a family—he has five children—and was spending his daylight hours, most of them, as a wallpaper designer in Buffalo. Nights and Sundays he painted. He even managed to spend thirty minutes of his lunch hour at his easel. In this period he held his first one-man show in New York, his watercolors were exhibited in London and Paris and were being collected by the Brooklyn Museum of Art, the Albright Art Gallery, Cleveland Museum of Art, Newark Art Museum, Metropolitan Museum of Art, Museum of Modern Art, Whitney Museum, Pennsylvania Academy of Fine Arts, and Phillips Memorial Gallery. By 1928 he felt secure enough to quit his job and devote his entire time to his beloved painting. Interestingly enough his per annum output since then has not exceeded that of the earlier period.

Yes, Burchfield made his name and place in art while he was still a Sunday painter. It might be said that he never had a chance, at least most men situated as he was would have said so. Living always in the Midwest, enjoying scant communication with art and artists, his inspiration was derived from nature and his own environment, rather than from the world of paint. He has never been abroad. Few artists have had as little contact with historic painting as Burchfield. He says he cannot recall having seen a Cézanne until 1920. He saw his first VanGogh in 1929. He thinks Japanese prints may have had some influence upon his design, although there was no conscious admiration for oriental art before 1918. His art is indeed one of the most isolated and original phenomena in American art.

Burchfield was born at Ashtabula Harbour, Ohio, in 1893. Five years later his family moved to Salem, Ohio, where he lived until 1921. It was here that the artist found many of his Main Street motives. He studied painting at the Cleveland School of Art under Henry G. Keller. During summers and until 1921 he worked as costs accountant in an automobile parts company. From 1921 to 1929, when designing wallpapers, he lived in Buffalo. Since then he has made his home in Gardenville, a small town a few miles east of the lake city.

Charles Burchfield would never be picked by a Hollywood director as an "artist type"—he is not "artistic." He is tall, powerfully built, as evidently devoid of temperament as a supreme court judge, and as reticent as a judge is supposed to be. He is a man of few words and the clichés of the *cognoscente* are not in his vocabulary. He is without pose and pretense. His outstanding characteristics are simplicity, directness and sincerity. Upon slight acquaintance one little suspects the depth of feeling that Burchfield's pictures so plainly tell us lie beneath a dispassionate exterior.

In order really to understand the emotional undertones in Burchfield's pictures one needs to be somewhat acquainted with his first experiments in which he attempted—in his early twenties—to re-create the sensations and emotions of childhood, to express the forebodings of childish imaginations; *The Night Wind*, for example. Of this the artist wrote, "To the child sitting cozily in his home the roar of the wind outside fills his mind full of strange visions and phantoms flying over the land." In *Church Bells Ringing* the church tower assumes a face like an African mask and sways with the swinging spiral motion and sound of the bells. Invisible sound and resulting emotion are thus expressed in visual forms. Even when he painted a straight nature subject like *The First Hepaticas* the same sinister quality seems to pervade its beauty.

When, through his more recent work, we think of Burchfield as a realist—he has been hailed as a pioneer in a new School of American Realism—we shall better understand him if we have thus had a glimpse of his early preoccupation with the melancholy aspects of nature and human experience. What more fitting subjects for the expression of this mood than the mongrel architecture of pioneer towns with their grotesque Gothic atrocities, the pretentious façades of false-fronted shops, muddy and slush-filled streets, dreary rows of jerry-built homes, ghost-like, deserted houses and the miscellaneous ugliness of an America growing up. Ugliness? Is not Burchfield that artist Emerson had in mind when he longed for a "genius in America with tyrannous eye, which knew the value of our incomparable materials and saw in the barbarism and materialism of the time another carnival of the gods"? Burchfield, at any rate, has made us all feel with him the strange and compelling beauty of things which, without the revealing touch of his brush, would seem devoid of all charm. On the other hand he does turn to subjects having a universal appeal, such as *The Great Elm*. Here the sun shines upon a farm where house and rambling barns are pleasantly viewed from beneath the spreading branches of the fine old tree. But more often it has been snow; wet, reflecting streets; leafless trees and lowering skies—all vehicles for expression of the "Burchfield mood."

What he says about the effect of music upon his art indicates the emphasis he places upon mood and emotion. Referring to Moussorgsky's songs he says, "They are a great stimulation to me. I feel that painting ought to be like that—not necessarily gloomy or tragic, but it ought to speak directly to us. The painter ought to paint directly the emotion he feels, translating a given object or scene without detours."

Music, it thus appears, is a constant source of creative nourishment for Burchfield. "Victrola music," he says, "is the nearest thing to a hobby, I have. I love canned music and listen to it a lot."

The romantic and poetical basis for his painting experiences is also revealed in his occasional practice of painting his picture in words before taking up his brush. Here is what he wrote about *Sunday Morning*.

THE NIGHT WIND 1918
A. Conger Goodyear Collection

THE FIRST HEPATICAS 1917
Collection Museum of Modern Art

SUNDAY MORNING Privately Owned

IN A DESERTED HOUSE Courtesy Rehn Gallery

"It is Sunday morning in mid-August. The day crawls slowly around from a dull listless dawn. Gradually there swells into a chorus the irritating 'tick' of countless insects—the sounds proceed from crab-grass and scrawny ragweed standing despondently in the dismal heat. Down a sun-drenched street, whose vista extends out to fields of Queen Anne's lace and chicory dim with hot steam-like mist, come languidly the worshippers. Those who come from out in the country have come over a dirt road which is lined with dust whitened weeds. Just before the road crosses a one-track railroad, and widens out into a brick-paved street, it passes a wretched farm which has an ill-smelling pig-pen from which issue grunts and squeals. (The memory of this sight influences the character of the clouds mounting up into the sky, giving them a tired tawdry look.) Those who come from the town have passed lawns which idly moving hose-sprays have failed to keep green—lawns adorned by oversized canna beds.

"A few early arrivals are clustered about the entrance, talking of the heat. There is the inevitable heavy-set lady with raw sunburned face and neck, dressed in a blue and white flowered dress, fanning herself. One by one, after desultory greetings have been exchanged, they file into the church. A brief silence; then the opening hymn, followed by the 'responses', another hymn, and presently is heard the hollow voice of the minister, delivering the sermon. The world outside is left to itself.

"(The foregoing is a sort of preliminary mood. Somehow or other I could not make the eventual picture fit into the realistic manner that such a description calls for. The mood from here on changes, becomes more mystical, and abandons almost completely the ironical touch. The last sentence should be repeated to open this mood.)

"The world outside is left to itself. White clouds that have a melted look appear in the faded hot-blue sky; they seem to struggle upward towards the sun, like moths seeking annihilation in a flame, trailing behind them shadows across the sky like dark rays. Pale orange sunlight, that strikes the bizarre steeple with quivering intensity, seems to die before it reaches the base of the church. Round about stand tall gaunt poplars—for once these normally nervous, quaking trees stand motionless, shrouded in a warm violet haze. From the top-most branches of one comes the pulsating metallic drone of a cicada, which

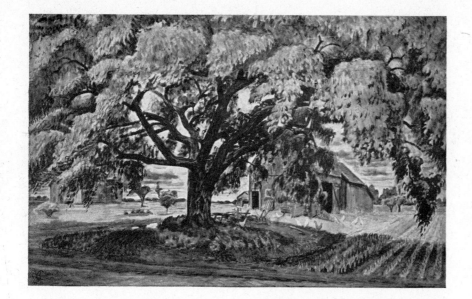

BURCHFIELD
WATERCOLORS

THE GREAT ELM
*This watercolor, painted in 1941, is
34x54 inches; the largest Burch-
field has ever attempted*
Rehn Gallery

OLD HOUSES IN WINTER
*Recently acquired by the Swope
Art Gallery, Terre Haute, Indiana,
from Rehn Gallery. It is 28x43*

SILVER LIGHT
*Painted in 1940. This watercolor is
23x33 inches.*
Rehn Gallery

mingles with the voice from the church, sounds that only seem to emphasize the profound silence that has settled down over the town. Clouds, trees and church all seem to yearn upward, ever upward."

One of the most striking examples of Burchfield's preoccupation with mood is his watercolor, *In a Deserted House*. This is as melancholy and empty a subject as one can imagine. Yet it must have had a haunting fascination for Burchfield—it was started in 1921 and laid aside unfinished for many years. In 1939 it was brought out and completed. This practice of reviving pictures left unfinished is by no means uncommon. *Old Houses in Winter,* here reproduced, was likewise completed in 1941 after a twenty-year interval. In thus returning to an old theme Burchfield invariably works directly upon the original picture. He declares that having once put his feeling into the theme he is more successful in carrying on with the first attempt than in starting all over again. His method of working makes this possible, for his watercolors, it will be noted, are painted quite dry in contrast to the more general fluid method which does not encourage working back into the washes.

Most of Burchfield's subjects are found within a stone's throw of his home, figuratively speaking. He is the kind of artist who is always discovering something new in old, familiar things. A chance view of neighboring houses through the branches of a leafless tree gives excitement to a commonplace scene. The wood shed in his back yard suddenly reveals itself as a thing

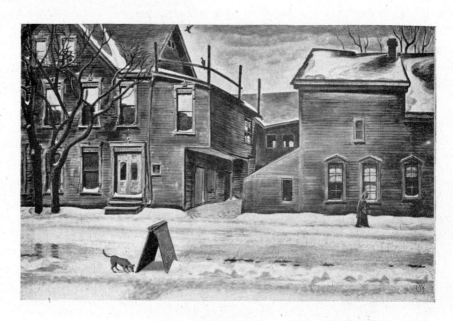

Photos on facing pages by Juley

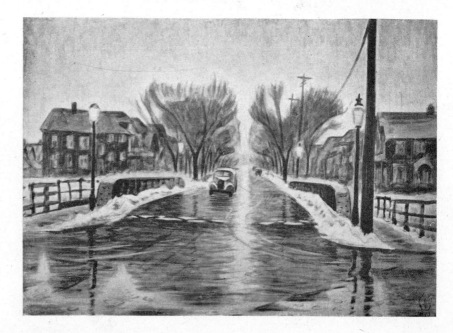

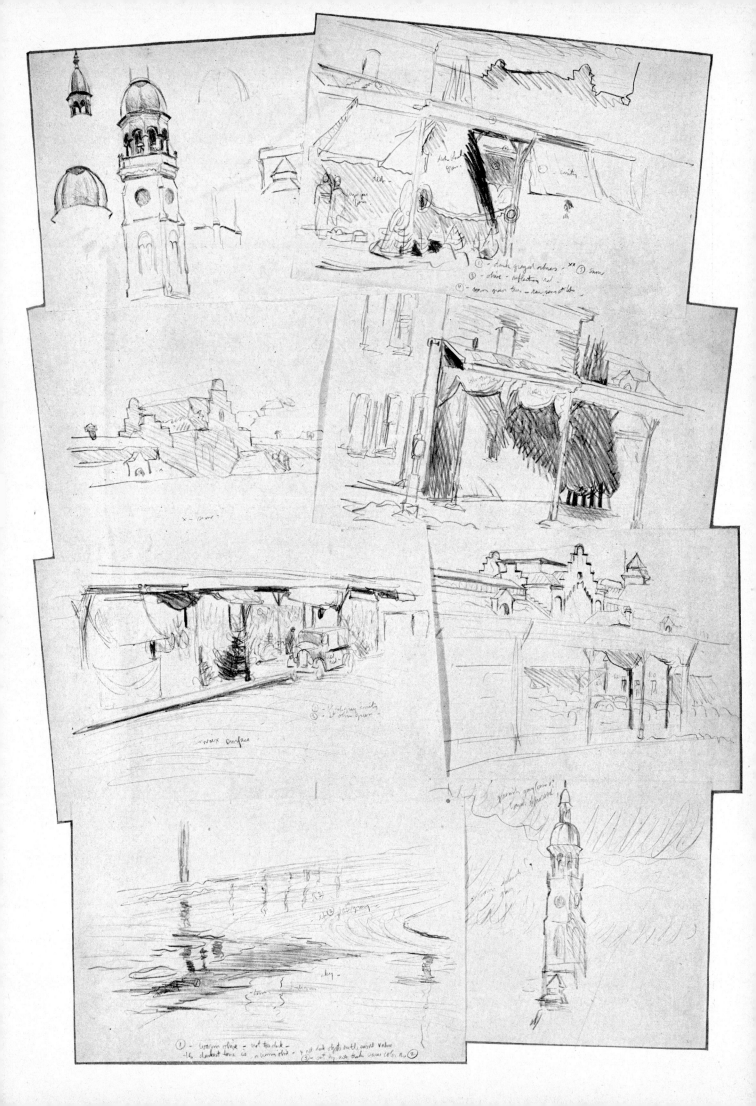

THE MARKET AT CHRISTMASTIME — WATERCOLOR BY CHARLES BURCHFIELD

This watercolor, owned by the Whitney Museum, is 43x26 inches. It was painted in 1941

On the page opposite, a few of about twenty-five pencil studies for this picture are shown. They are on 11x17-inch sheets

The drawing at the right is the only complete drawing of the subject that Burchfield made. It is far from a "working drawing" but it serves as a compositional layout which, by means of squaring-up, permitted transfer to the watercolor paper. This drawing is 9x15 inches

of beauty when seen under some unusual condition of light or his own mood. A drainage ditch running along a concrete highway with telegraph poles and a tree or two will send him back to his studio filled with desire to paint.

Burchfield, as has been noted, has been but slightly influenced by the work of either his contemporaries or the old masters. He is, accordingly, free from traditional conceptions of picture making, from certain time-honored taboos. Thus we find him cutting his *Silver Light* nearly in half by the light sky reflection in the wet street and treating each half of the picture with almost mechanical symmetry. Yet through compositional subtleties he not only saves the

day, he achieves a result of unusual distinction. In *March Road* the road and row of trees leading off almost to the frame at the right is another daring violation of an academic prohibition. Burchfield knows his design; he has an unerring sense of structure in form and pattern. This is intuitive but it is also applied analytically. Among the many pencil studies for *The Great Elm*, for example, are several which are purely diagrammatic—experiments in the design of that great foliage arch in its relation to other elements in the picture.

Burchfield's creative processes vary, naturally enough, with the kind of experience he is having. We have seen how he sometimes broods over a picture for

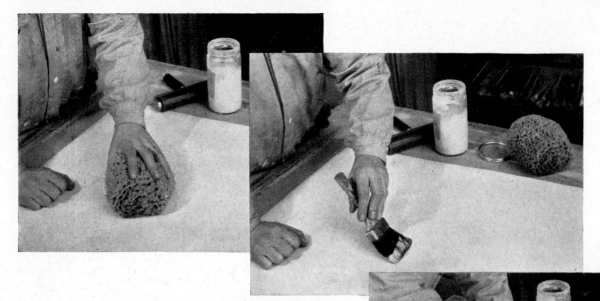

MOUNTING A SHEET OF WATERCOLOR PAPER

Burchfield's usual practice is to stretch his paper, regardless of its weight. These pictures show the three operations: wetting the paper (on both sides) with a sponge; applying library paste with a three-inch varnish brush; smoothing down the sheet on a piece of one-eighth-inch cardboard. To prevent warping, another sheet of ordinary wrapping paper is moistened and pasted to the reverse side of the cardboard. The mount is put in press to dry

Below, we see Burchfield's outdoor sketching outfit which he has set up in his studio for the photographer. The guy ropes hold easel secure on a windy day. In the photograph on page 1 he is seen starting out on a sketching trip. The leather belt, over his windbreaker, supports the easel slung on his back and the pouch at his side containing paints, palette and brushes

a long time before his conception is finally realized. At other times he goes out with his sketching kit and returns in a few hours with a completed painting. But most of his pictures are carefully studied and our reproduction of his studies for *The Market at Christmastime* demonstrates his usual procedure. He will make a great many pencil drawings on location, familiarizing himself with every detail and color aspect.

These drawings may or may not be referred to when he finally begins his painting, but through them he has absorbed both the factual and emotional content of the scene. They are not so much sketches as diagrammatic data with written notes of colors and effects. It will be observed that even in the final pencil composition which is squared up for transfer, the forms are indicated rather than meticulously defined; he leaves as much as possible for his brush to do.

Examining a complete set of these pencil sketches one is impressed by the thoroughness of his study. In *The Market at Christmastime* series, for example, there are drawings of as inconsequential details as the base of the lamp post, with written notations of color; there are a half-dozen drawings of the slushy street, full of scribbled notes; and innumerable details which do not even appear in the picture.

The Great Elm is the largest watercolor Burchfield has ever made; it is 34x54 inches. To secure a large enough paper he had to enlarge a 24x36 sheet by adding strips all around, mounting all on a heavy piece of cardboard. To do this he cut the edges with a razor

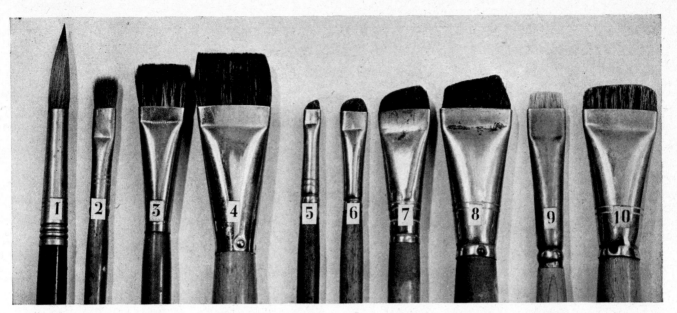

CHARLES BURCHFIELD'S WATERCOLOR BRUSHES —— REPRODUCED AT THREE-QUARTERS SIZE

blade along a metal straightedge. When carefully cemented to the board, with edges butted together, the seam was scarcely noticeable. Regardless of the weight of paper he always mounts it on one-eighth inch cardboard.

Our discussion thus far has related only to Burchfield's watercolors. While he does not employ this medium exclusively, he greatly prefers it to oil. "My preference for watercolor," he says, "is a natural one. To paint in watercolor is as natural to me as using a pencil, and presents no more difficulties than a pencil; whereas I always feel self-conscious when I use oil. I have to stop and think how I am going to apply the paint to canvas, which is a detriment to complete freedom of expression. It is like a speaker pausing in his talk to get just the right word. To me watercolor is so much more pliable, and quick. For instance, you decide that a whole passage is undesirable; you take a sponge and wipe it out in a few seconds. To do the same thing in oil is more complicated and takes more time.

"Basically, the only difference between oil and watercolor is one of vehicle. Obviously dry-cake watercolors require a certain method of application to paper; but tube watercolors are the same as tube oils, except that gum arabic and glycerine are used with the pigments in place of oils or varnishes. Both are, in common practice, transferred to linen fibres, the one in the form of paper, the other as woven cloth. The fact that water is the thinning medium for watercolor, to my mind, makes it much easier to handle in all respects.

"Many authorities think that watercolors are more permanent than oils; whereas the general public mistakenly thinks of watercolor as a slightly less durable medium. There needs to be education carried on in this respect."

Charles Burchfield's paintings are steadily being acquired by America's art museums. During the past winter, for example, four watercolors were added to museum collections. No American painter has more widespread recognition.

Photos on facing pages by Hare

BURCHFIELD'S
WATERCOLOR BRUSHES

No. 1 is a red sable, pointed brush used more or less infrequently in the conventional manner. Nos. 2, 3, & 4 are straight black sable "brights"—for all manner of painting. Nos. 5, 6, 7 & 8 are "brights" which have been trimmed diagonally—used for drawing and painting. Nos. 9 & 10 are pig-bristle "brights" cut off short—used for scrubbing out details that are to be eliminated. These are typical; there are others in different sizes. His practice of trimming his brushes diagonally was suggested by the manner in which they naturally wore down as he painted. Burchfield, by the way, is left-handed

HIS PALETTE

This close-up of Burchfield's palette gives more than a hint of the artist's technical practice. Note the character of the brush smears; they indicate his "dry" manner of handling color

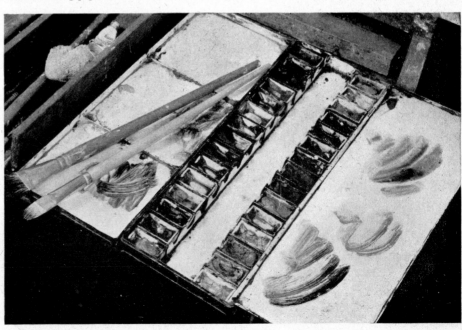

11

EUGENE SPEICHER

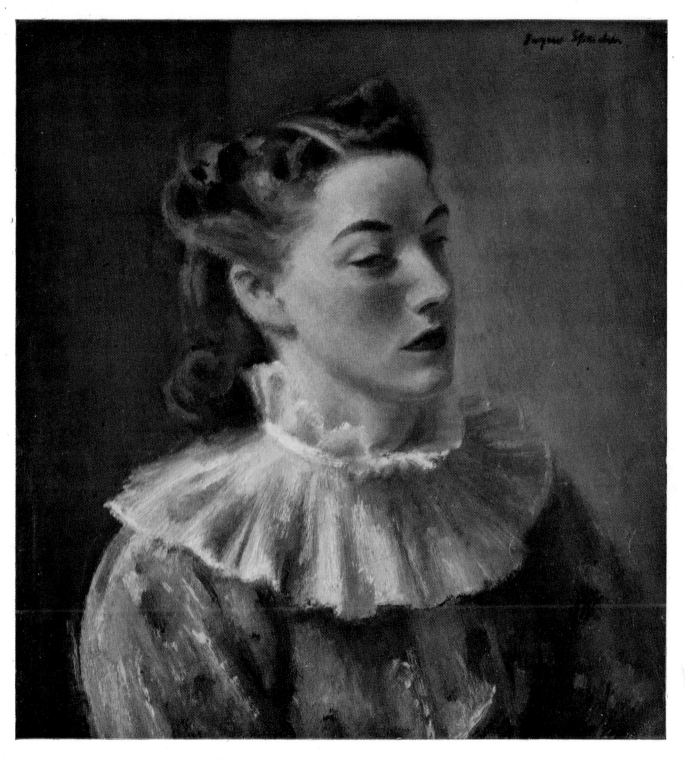

DANISH GIRL BY EUGENE SPEICHER

Courtesy Whitney Museum

Eugene Speicher

"I believe in skill, properly used, and know of no master who is not a master craftsman. Vital expression can be thrown into vivid relief only by the conquering of one's means. My work can be no greater than I am, and continual enrichment of my life is of great concern to me. Any subject that releases me and sets my creative faculties in motion, I believe to be an adequate subject. It is what I take to the subject that is of importance. When I successfully express myself, my work is auto-biographical and registers what appreciation and understanding I have of life."

In these brief words Eugene Speicher gives us his painting credo and the philosophy of a life wholly consecrated to the attainment of a goal upon which, with singleness of purpose, he has focused every energy since he began his painting career.

Virgil Barker, writing about Speicher in *The Arts* a few years ago, extended this thought and gave an estimate of the artist's success in measuring up to that high standard; an estimate which is so commonly accepted by contemporary opinion in the world of art that I beg leave to quote it here.

"Eugene Speicher," says Mr. Barker, "knows that the only way to equal the old masters is to live on the same artistic level as they; and since they have made that level their own, any later artist must become accustomed to living in their company. It is doubtless a strain to be subjected to the intimate scrutiny of such personages, and small natures will not endure it. The great ones who keep the heights will admit to their company only that newcomer who can show them coins of their own minting which ring as true as theirs. And of all the coinage of today none rings more musically pure, none is more likely of acceptance by the keepers of the heights, than that stamped with the image and superscription of Eugene Speicher."

This appraisal, so gracefully expressed by Mr. Barker is, as he has said, quite generally held in authoritative art circles. "If it were put to a public vote," writes a prominent New York critic, "there is scarcely any question but that he would be elected to the position of No. 1 artist among living American painters." "The only museums," writes another, "which have not Speicher's paintings are: (1) those which are going to get them, and (2) those which cannot afford the luxury." He might have added that no museum in the country considers its American section representative without at least two Speichers in its permanent collection, a portrait and a landscape or a flower painting.

It is in the field of portraiture, of course, that Speicher has so distinguished himself as to be thought of as a contemporary "old master." But he is not the usual kind of portrait painter, the kind who will accept a portrait commission from anyone who can afford to bid for his services. Speicher has repeatedly declined to paint "personages"—so that he will be free to paint *Josephine, Pattie, Susan, Anna*, the daughter of a local tradesman, and *Red Moore*, the blacksmith in a neighboring village. That does not mean he will not paint "important" people. He does and will, provided, as he explains, "the picture I can see in that person, as well as the person, interests me." So he picks and chooses whom he will as his models, with well-justified confidence that the canvas

will hang in the gallery of a museum or in the house of a private collector, if not in that of his sitter. In any case, the canvas will not leave Speicher's studio unless he believes he has painted a first rate picture, a picture that, like a portrait by Rembrandt, Titian or Renoir, has qualities that overshadow the purely transient virtue of likeness to sitter. While Speicher always has had an extraordinary faculty in expressing the sitter's personality, that is a purely incidental achievement in a Speicher portrait. "My look and feel of the thing," he says, "my imagining and thinking about the thing is what I try to express, be it a portrait, figure, landscape or a bunch of flowers.

"I try for a mysterious and living design made through the form of the canvas. By 'form of the canvas' I mean all the contributing elements *on* the canvas; this is not to be confused with forms or solidity."

Again, "I try for quality of statement, living calm, and strong grace, uniqueness, warmth—and a general push away from the obvious."

When Speicher says, "My work is autobiographical," he means that every portrait must first of all be a good "Speicher"—that it must embody all that he is and has accumulated in technical knowledge and insight throughout the years.

This sublime freedom to paint what one desires and in what way one chooses may well be the dream of many a portrait painter, but it is a dream not likely to be fulfilled in the career of a painter of commis-

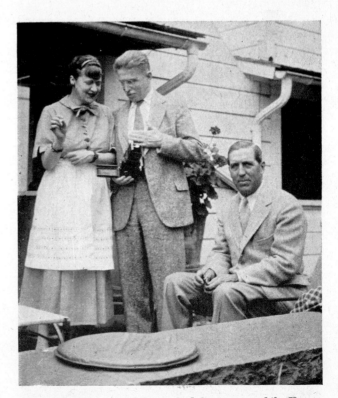

Eugene Speicher poses for a kodak picture, while Homer Saint-Gaudens explains the mysteries of his camera to Mrs. Speicher

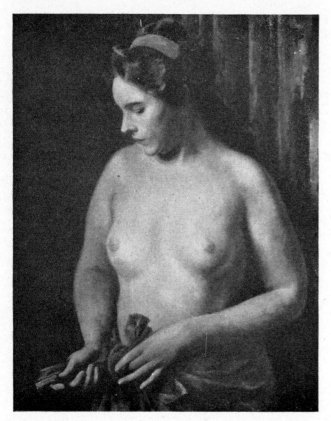

TORSO (24x30) PAINTED IN 1920
Collection of Mr. Carl Hamilton

In this early canvas, as in all of Speicher's figure compositions, the human attributes of allure and vitality are appreciatively portrayed; but there is a quality of serious aloofness and repose which, for all his appreciation of femininity differentiates it from a Latin interpretation of a similar theme

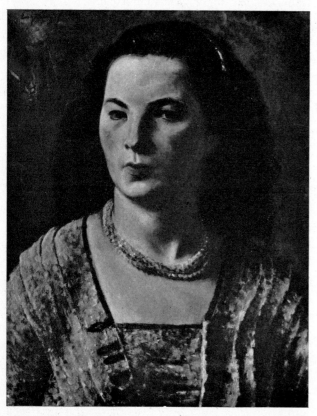

SOUTHERN SLAV PAINTED IN 1923
Collection of Mr. Oliver Thompson

sioned portraits, who, in the very nature of the situation, has to focus upon that objective which is uppermost in the mind of the sitter.

Time was when you could have commissioned a Speicher portrait—and for as little as twenty-five dollars. That was back in his student days while he was getting his first formal instruction at the Art Students League, in the classes of William M. Chase and Frank Vincent DuMond. Each weekend he was doing portraits in three sittings. His patrons—many of them—were people of taste and culture who, even then, recognized the first flowering of a brilliant talent. Among these were Editor Henry Mills Alden; Mary Wilkins Freeman, famous New England author; the present Mrs. Leopold Stokowski and the present Mrs. Joyce Kilmer.

His first formal recognition came while at the League, with the winning of the Kelly Prize for a portrait of *Patsy O'Keeffe,* a fellow student, now the well-known Georgia O'Keeffe. That was the beginning of a continuous stream of prizes and honors which continue to flow in ever increasing volume.

It was fortunate that Speicher, after leaving the League, came under the guidance of Robert Henri who is known as the greatest teacher in American art, and who was impelled by the same ambition that is directing his famous pupil. Henri assessed young Speicher's genius and encouraged his determination to become a portrait painter.

That was in 1909. In the early twenties Speicher had become an outstanding and fashionable portrait painter. He found himself able to accept but a few of the many commissions offered him by people who didn't need to inquire the price. He concentrated upon six portraits a year. His position was the envy of every aspiring artist in the portrait field. But it was not in line with his ambition. "The passion for *painting* is what I live by," he declares, "and as I grow older that passion increases. I want to paint portraits as they should be painted—to paint only the people who interest me, and paint them as I want to paint them."

Because Eugene Speicher is an artist first and a portrait painter by *accident*—shall we say—he has been able to fulfill this ambition. Having fulfilled it he continues to practice his art with the same humility and the persistent striving for perfection which has always been so characteristic of the man. Although current fashions and tendencies in painting have never turned Eugene Speicher aside from his predestined path he has always been an avid student of the "New Movements." He has not, according to Helen Appleton Read, "emerged with 'Speicherized' versions of the French moderns, but with Speichers immeasurably enriched in technic and ennobled as to conception."

It was my privilege to meet Eugene Speicher first in his Woodstock, New York, home, a beautiful though unpretentious home that has gradually evolved from a tiny cottage to which the artist took his young bride in 1910. Here in the order and organization for fine living one sees an expression in environment of those qualities which are fundamental in Speicher's painting. In the home, to be sure, the pattern for living is a cooperative affair; Mrs. Speicher, who is famed as an imaginative as well as a practical homemaker, is the best possible partner for her artist husband. But in the studio, which is a three or four minute walk from the house, and which is the artist's exclusive domain, the same order and evidence of efficiency prevail. There all is shipshape. Everything has its place and is in it. In the closets provided for

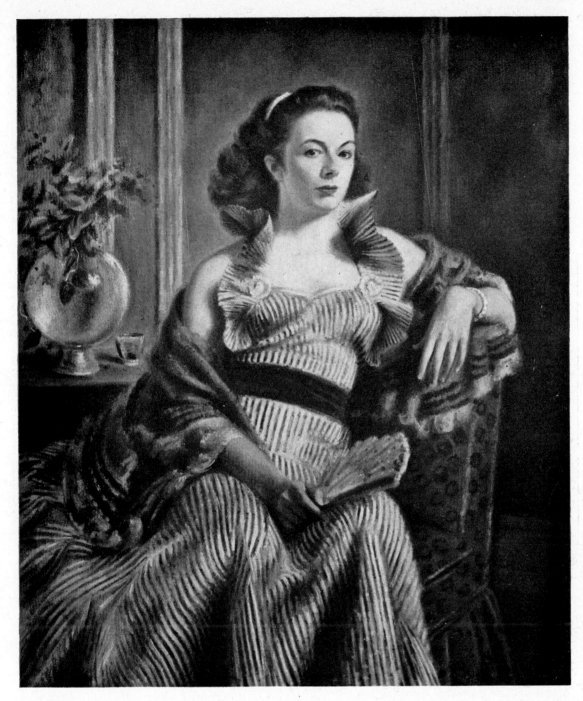

art materials and accessories, brushes, paints, drap-
eries, canvases and frames are as neatly arranged as
the shelves of a well-kept shop. There are no glory-
holes nor is there any clutter of useless impedimenta.
It is a workshop thoughtfully planned and maintained
for a single purpose—the production of works of art.
A huge four-paneled screen forms an alcove for the
model stand upon which, when I saw it, stood an
empty chair; empty, yet how eagerly it invited the
imagination to fill that alcove with successive visions
of *Babette, Alicia, Mary R.* and *Danish Girl;* and all
those other alluring and illusive young women who,
by sitting in that chair, have become candidates for
a coveted immortality. Men, to be sure, have sat in
that same chair, but women inspire Eugene Speicher
to his most notable achievements.

Speicher's palette is a sheet of "milk" glass set into
the top of a painting cabinet; he prefers to see his
colors against a white ground. Every day, after paint-

ing, all color is removed from the palette and the glass
wiped clean.

Brushes? There must be hundreds in that studio.
They fill drawers and jars and they range in size from
enormous bristle brushes to sables tiny enough to
paint a mouse's eyebrow. Like Delacroix, Speicher
"starts with a broom and ends with a needle."

Speicher insists upon a very clear idea before he
begins to paint which sometimes necessitates making
drawings and color sketches in pastel. In that way he
crystallizes his conception, solves problems of form
and prepares himself for a direct attack on the canvas.

His draftsmanship is, of course, impeccable. And
in his pictures the drawing of no detail is slighted.
His drawing of hands—a rather good test of drafts-
manship—is always noted as a strong contributing
element in his figures and portraits.

And his painting procedure? That is best described
in his own words which follow: "On a well-prepared

Eugene Speicher's Palette

First Painting	Subsequent Painting
White lead	Zinc white
	Cadmium Yellow - Lt.
Yellow ochre	Yellow ochre
	Cadmium red
Indian red	Indian red - deep
Light red	Light red
	Alizarin crimson
Raw umber	Raw umber
Burnt umber	Burnt umber
	Burnt sienna
Terre verte	Terre verte
	Emeraude green
Ultramarine	Ultramarine
	Ivory black

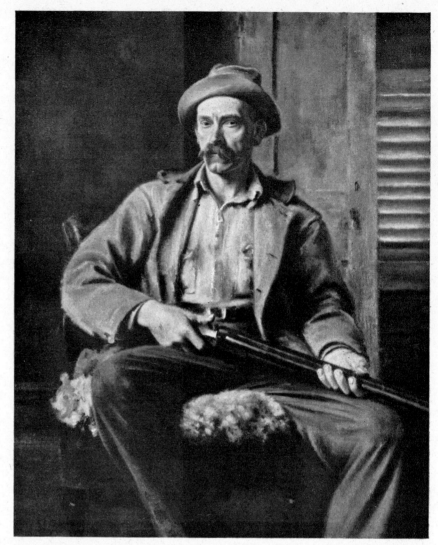

RED MOORE, HUNTER 1938 Rehn Galleries

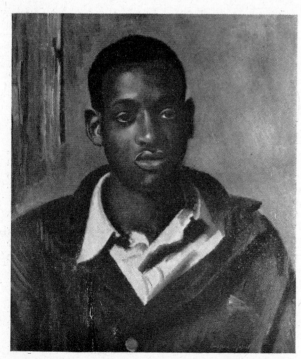

HEAD OF A NEGRO 1933 Rehn Galleries

20

linen canvas I first wash the surface with double rectified turpentine to remove excess chalk which is applied to canvas by manufacturers to facilitate rolling.

"With white lead, yellow ochre, indian red, light red, terre verte, ultramarine blue, raw umber, and burnt umber, I use double rectified turpentine as a thinner. This will dry hard and fast, and I am careful in the first painting not to use too much pigment, so as to preserve the tooth of the canvas throughout its surface.

"In this first painting, which is really a thin wash, I try to approach the finished look of the canvas; that is, I think of what I am trying to express with as much clarity, sensitivity and vitality as I am capable of with this limited, fast drying palette.

"The second painting is in the same vein, developing the movement of volumes, differentiation of areas, textures and other elements of design. Then when these qualities are near to my liking and well dried, I change my palette, replacing lead with zinc white and using cadmium light, yellow ochre, burnt ochre, cadmium red, light red, indian red deep, burnt sienna, terre verte, emeraude green, alizarine crimson (only when necessary), ultramarine blue, raw umber, burnt umber and ivory black.

"I use more pigment from now on. When I want fluidity I use a fluid zinc white; when I want more

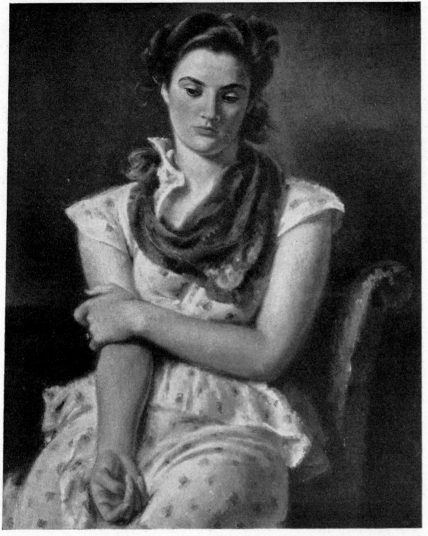

WELSH GIRL 1940 Collection of Edward G. Robinson CONTÉ CRAYON DRAWING

body and a 'cheesier' quality, I put the white on an absorbent paper which sucks some of the oil out of it to the thickness I desire.

"I wash my brushes in turpentine continually and use no other medium.

"In this last painting, when most of the important decisions have been made, I start at the heart of the canvas and paint the entire surface *in one wet skin* until I get exactly what I want for the finished result. This does not mean that the entire canvas dries simultaneously. It does mean that no part of it is permitted to dry until it is entirely finished. The head, for example, having been completed to my satisfaction will be allowed to dry while I go to the other areas. In no case, however, will I go back over the head or any other part, in this final painting, after it has dried. This last painting takes more generalship to sustain the living interest to the end.

"To keep the canvas wet from day to day it should be put overnight in as cold a place as can be found. Leonardo, you know, kept his canvases in a pit dug in the ground for the purpose. The fire escape of my 60th Street studio serves well during the winter."

Eugene Speicher uses his color as an athlete uses his strength; he knows when to hold it in reserve and when and where to expend its full force. Although you will see very little brilliant pigment in his pictures they impress one with their sense of fullness of

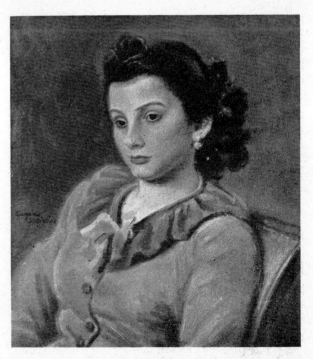

JOSEPHINE 1941
Rehn Galleries

MURRAY BAY LANDSCAPE, CANADA , 1933 WHITNEY MUSEUM

DAHLIAS 1933 Collection of Mr. and Mrs. Lesley G. Sheafer

In the summertime Speicher devotes a part of his time to landscapes, and flowers picked from his own garden

color. In an unusual way his color is form and his form color. He has a preference for what are known as "off colors." "I try," he says, "for the color of the whole canvas instead of colors *in* the canvas. I go to intensity when the subject needs it, but, as in all order, quantities and intensities are ordered for the sake of the whole. Local colors are therefore always affected by their surroundings and lose their identities in the whole scheme."

Eugene Speicher's work habits are as well ordered as his environment and his painting procedure. He is in his studio about every day from nine until one and from two to five. He does not paint feverishly for a few days and then sit around for a spell waiting for another inspiration. His performance, like that of other painters, is uneven. He paints better some days than others, but always he paints. He says he believes in being before his easel when the sparks fly. And when the sparks do fly, when there comes that flash of an inspired idea, the great thing is to keep it ever in focus throughout the painting days that follow. "In painting," he says, "I keep my eye on my first enthusiasm with the same intensity as a golf player keeps his eye on the ball. Success depends upon that in both sport and painting." It is not a simple thing to do. Speicher usually manages to do it throughout four, five, six or more weeks of steady painting, establishing it for all time in the pigment of his canvas.

"Painting," says Speicher, "is like playing with electricity. Touch the brush to one part and something immediately happens at the opposite side of the canvas. One part must be played against the others, gradually bringing the whole into a state of balance and unity. And unity in a work of art is one of the most distinguishing qualities, as is style. In a well-organ-

CRAYON DRAWING OF A HEAD (8½ x 11)

ized canvas parts lose their identity, facts disappear, miracles happen."

Every Speicher painting is a carefully thought out design. "An artist," he says, "is a distinguished shape-maker: shapes in three dimensions, variety in shapes. I believe that all art is built on a substructure of abstract design (balance, movement, texture, line, color, volume, etc.) upon which and out of which the original idea flowers. Naturally in believing this I am trying to acquire adequate technical facility and concentration to express myself as clearly as possible. I don't like stuttering or double talk in paint any more than I do in real life."

What about Speicher the man? Physically he is built on generous lines. He is just a shade under six feet in height and tips the scales at about 185. He is 59 years old and doesn't look it. He is vigorous and has the ruddy complexion of an athletic man who spends sufficient time out of doors and keeps fit through exercise. Someone has said he "looks like an athlete turned thoughtful;" a most apt description, for the man expresses in his physical aspect that "living calm and strong grace" that he tries to put into his pictures. While in his Woodstock home he spends considerable time gardening and doing things about his place. He can build a fence—even a porch for his house—lay a flag walk, and do minor carpentering jobs. He takes a little time off now and then for a game of golf. In the city, where the Speichers spend the five winter months, he keeps fit by playing hand tennis and squash. There are of course the periodic vacations when Speicher locks his studio door for a few weeks and journeys afar. He and Mrs. Speicher have visited nearly every European country.

Eugene Speicher is popular with fellow artists and is in demand on juries for the big shows. He has served on the Carnegie International jury and was one of the judges of the Guggenheim Foundation for several years. He is, in short, a distinguished American artist of whom America has a right to be proud.

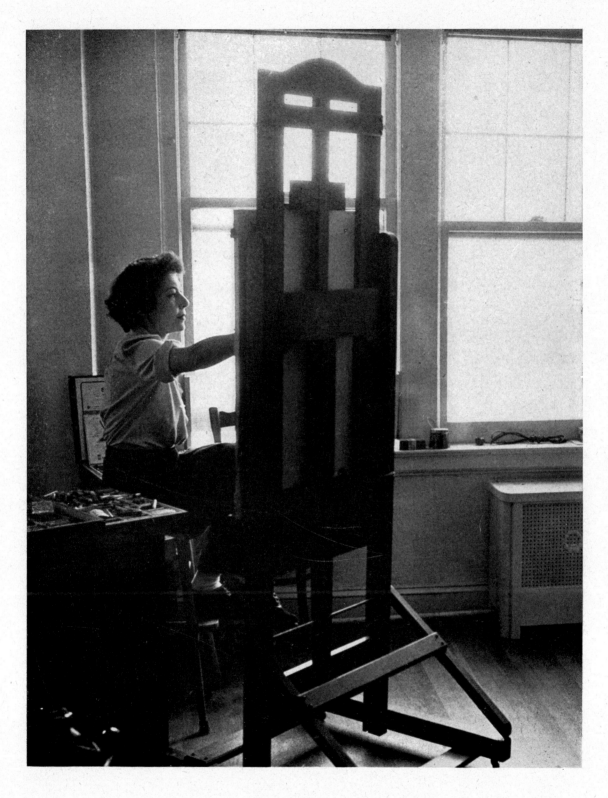

GLADYS ROCKMORE DAVIS

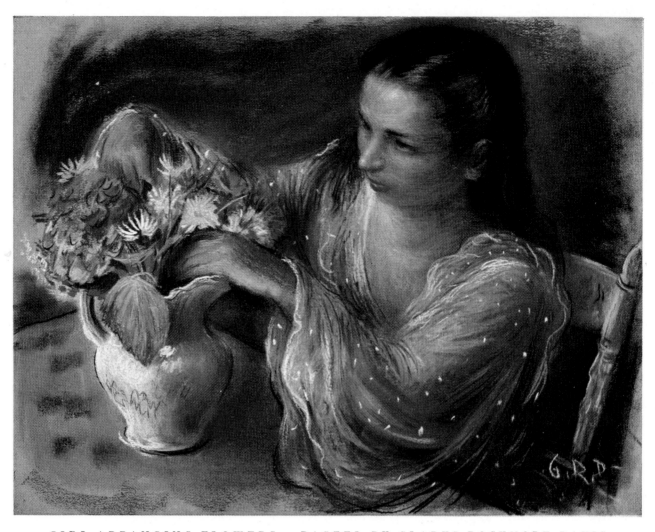

GIRL ARRANGING FLOWERS——PASTEL BY GLADYS ROCKMORE DAVIS

Courtesy Midtown Galleries

Gladys Rockmore Davis

Her Adventure in Pastel

THERE have been few women artists in America who have attained the success that Gladys Rockmore Davis enjoys today, just ten years after she began to paint. Ten years is a short time in the development of a career, especially when the responsibilities of a home and two young children claim their share of time, thought and energy. Yet during that decade Mrs. Davis has been as prolific in her painting as many artists whose art wholly commands their attention.

But it is not quantity that concerns us, no matter how greatly we may marvel at the sheer accomplishment of producing so many canvases. The early pictures she exhibited bore the imprint of originality and gave promise of what was to come; it was evident she was a person to watch. By the time of her first one-man show in New York in 1940 she had won her place in the front ranks of American art.

Perhaps it is misleading to designate the year 1932 as the beginning of Mrs. Davis' career—that is when she began to paint—because for eleven years previously she had been a very successful advertising and fashion artist. Thus there was behind her a considerable experience which, while not usually considered a promising kind of background for a painting career, appears to have equipped this artist with sound skills which she successfully applied to the problems of easel painting.

The transition from fashion artist is interesting and involves a bit of history. In 1925, five years after her graduation from the Art Institute of Chicago, she married Floyd M. Davis, who, even then, was a well-known illustrator and advertising artist. They moved to New York where their two children were born in 1930 and 1931. Mrs. Davis continued her fashion work until 1932 when, with bag, baggage, babies and nurse, the Davises sailed for Europe. After touring about for a few months they settled in Cannes, quite near the house in Le Cannet where Renoir spent the last twenty-five years of his life. The visits to the Renoir home and studio made a lasting impression; the great Frenchman has been a noticeable influence upon Mrs. Davis' work.

At Cannes she took up her brushes and painted steadily until the family returned to America a year later. "I discovered, to my surprise," she recalls, "that I had completely lost my flair for commercial work. After

floundering for a couple of months I decided to attend the Art Students League of New York. There I spent several more months studying, painting and thoroughly enjoying myself. Following that I studied for a time with George Grosz. Then I threw away all leading strings and plunged myself into the strange world of painting."

Mrs. Davis had not been painting long before the critics noted that a new star had appeared in the firmament of the art world. In 1937 the Metropolitan Museum of Art acquired her *August Afternoon,* an important landmark in her rapidly developing career. Since then her work has been reproduced continually. She was the subject of a feature article in the January 1940 number of *Magazine of Art.*

BRILLIANT PASTELS

Gladys Rockmore Davis scores with her outstanding work in this medium

These are the words with which one of New York's newspaper critics hailed the opening of Mrs. Davis' exhibition of pastels in November 1941 at the Midtown Galleries. Another critic wrote—"She handles pastel very much the same way she uses oils, getting a lush richness and Renoir-like glow in the colors. Also the subjects that are the most successful are those that have given her oil paintings such distinction—pensive girls and young women in natural, unposed attitudes." "In none of her pastels," observed another, "is there a hint of the pale lavenders, the feminine pinks usually associated with the word 'pastel.' The chalk medium has responded to her love of strong, rich color."

The pastels seen in this exhibition, executed during the past year, represent the artist's first work in the medium. And now, after this brief but highly successful excursion in the new medium, she has laid aside her chalks to take up her familiar brush once more. What prompted this pastel period? She was attracted to the medium, she declares, because it enables the artist to execute, in a few days, a portrait which, in oil, would occupy several weeks of continuous painting. A portrait commission in pastel, it follows, is not such an expensive luxury—it is within the means of a wider public.

The use of pastel as

SALLY — PASTEL
Gladys Rockmore Davis

29

Gladys Rockmore Davis

Her Adventure in Pastel

THERE have been few women artists in America who have attained the success that Gladys Rockmore Davis enjoys today, just ten years after she began to paint. Ten years is a short time in the development of a career, especially when the responsibilities of a home and two young children claim their share of time, thought and energy. Yet during that decade Mrs. Davis has been as prolific in her painting as many artists whose art wholly commands their attention.

But it is not quantity that concerns us, no matter how greatly we may marvel at the sheer accomplishment of producing so many canvases. The early pictures she exhibited bore the imprint of originality and gave promise of what was to come; it was evident she was a person to watch. By the time of her first one-man show in New York in 1940 she had won her place in the front ranks of American art.

Perhaps it is misleading to designate the year 1932 as the beginning of Mrs. Davis' career—that is when she began to paint—because for eleven years previously she had been a very successful advertising and fashion artist. Thus there was behind her a considerable experience which, while not usually considered a promising kind of background for a painting career, appears to have equipped this artist with sound skills which she successfully applied to the problems of easel painting.

The transition from fashion artist is interesting and involves a bit of history. In 1925, five years after her graduation from the Art Institute of Chicago, she married Floyd M. Davis, who, even then, was a well-known illustrator and advertising artist. They moved to New York where their two children were born in 1930 and 1931. Mrs. Davis continued her fashion work until 1932 when, with bag, baggage, babies and nurse, the Davises sailed for Europe. After touring about for a few months they settled in Cannes, quite near the house in Le Cannet where Renoir spent the last twenty-five years of his life. The visits to the Renoir home and studio made a lasting impression; the great Frenchman has been a noticeable influence upon Mrs. Davis' work.

At Cannes she took up her brushes and painted steadily until the family returned to America a year later. "I discovered, to my surprise," she recalls, "that I had completely lost my flair for commercial work. After floundering for a couple of months I decided to attend the Art Students League of New York. There I spent several more months studying, painting and thoroughly enjoying myself. Following that I studied for a time with George Grosz. Then I threw away all leading strings and plunged myself into the strange world of painting."

Mrs. Davis had not been painting long before the critics noted that a new star had appeared in the firmament of the art world. In 1937 the Metropolitan Museum of Art acquired her *August Afternoon,* an important landmark in her rapidly developing career. Since then her work has been reproduced continually. She was the subject of a feature article in the January 1940 number of *Magazine of Art.*

BRILLIANT PASTELS

Gladys Rockmore Davis scores with her outstanding work in this medium

These are the words with which one of New York's newspaper critics hailed the opening of Mrs. Davis' exhibition of pastels in November 1941 at the Midtown Galleries. Another critic wrote—"She handles pastel very much the same way she uses oils, getting a lush richness and Renoir-like glow in the colors. Also the subjects that are the most successful are those that have given her oil paintings such distinction—pensive girls and young women in natural, unposed attitudes." "In none of her pastels," observed another, "is there a hint of the pale lavenders, the feminine pinks usually associated with the word 'pastel.' The chalk medium has responded to her love of strong, rich color."

The pastels seen in this exhibition, executed during the past year, represent the artist's first work in the medium. And now, after this brief but highly successful excursion in the new medium, she has laid aside her chalks to take up her familiar brush once more. What prompted this pastel period? She was attracted to the medium, she declares, because it enables the artist to execute, in a few days, a portrait which, in oil, would occupy several weeks of continuous painting. A portrait commission in pastel, it follows, is not such an expensive luxury—it is within the means of a wider public.

The use of pastel as

SALLY — PASTEL
Gladys Rockmore Davis

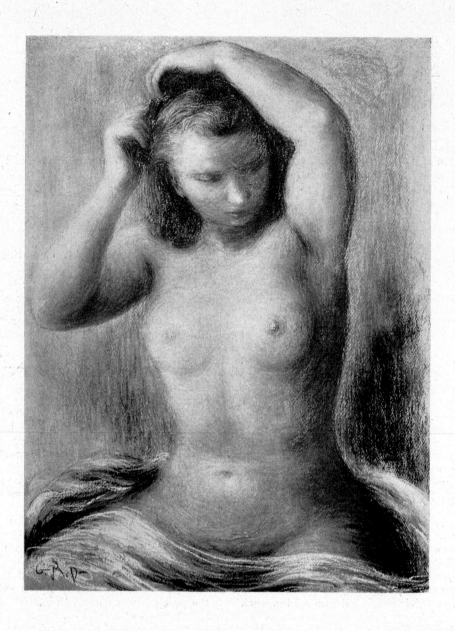

TORSO
by
*Gladys
Rockmore
Davis*

a *painting* medium has always been pretty much confined to casual undertakings, principally in the field of portraiture. It has not generally been looked upon as a medium for serious work, in spite of the achievements of not a few fine artists who have devoted themselves to it. Rosalba Carriera of Venice (1675-1757), who was one of the first to carry the art to perfection, is represented in the Dresden Museum by 157 of her pastel portraits. Quentin de la Tour (1704-1788), the most eminent pastellist France has produced, painted a great many notable portraits. Hogarth, Sir Thomas Lawrence and George Romney, among English artists, turned occasionally to the pastel medium. Mary Cassatt, that distinguished American painter with whom Mrs. Davis has been compared —merely because of her fondness for the mother and child theme—was particularly successful with pastel.

Pastel has been quite extensively employed as a *drawing* medium. One recalls Degas' innumerable studies of ballet dancers. Many of these are slight enough to be designated drawings; others were executed with a completeness approaching that of an oil painting. In the former the chalk has been chiefly used for delineation with no more than a suggestion of color; the paper, usually tinted, being a strong tonal factor in the result. In the latter the paper was often covered, or nearly so, and the chalks were handled in a painter-like manner.

Mrs. Davis' pastels are definitely paintings. She pretty much eliminates the paper as a color element even though she doesn't cover it all the way to the frame. She prefers fullness of representation to mere suggestion. Always a vigorous painter, known for her sculpturesque form and warm, glowing color, she succeeds in retaining these characteristics in pastel. She complains that the chalks do not give her quite the lush reds she is so fond of, but to critics of her sometimes too "hot" color this would seem to be a wholesome corrective.

In referring to these pictures as paintings we would not give the impression that Mrs. Davis, in her pastels, imitates oil painting technic. She fully appreciates the distinctive characteristics of the medium and exploits them intelligently; she does not attempt to force it beyond its natural limitations.

In turning from oils to pastels the painter has to adjust himself to the wholly different properties of the chalk medium. First to be noted, perhaps, is the extensive range of the pastel palette. Instead of a dozen oil colors which, through mixtures, supply his every need, he must have at hand between 150 and 250 sticks of chalk. Because the possibility of mixing

EMMA —— OIL PAINTING BY GLADYS ROCKMORE DAVIS

pastel hues on paper is very limited the manufacturer has anticipated nearly every color need including, of course, the greatest variety of warm and cool grays. Pastels are usually arranged in a series of tones, the darkest ones consisting of pure color; the others of the series are mixed with white to a greater and greater degree as they ascend the scale toward the lightest.

Because the colors cannot readily be mixed and because the paper will hold but a limited amount of pigment, work in pastel has to be very direct. Pastel tones may be rubbed with the fingers or a stump, but the juxtaposition of colors and hatching give a more vibrant result. A certain amount of impasto may be desired here and there to suggest flesh quality. This, with reserve, is seen in Mrs. Davis' portraits; but most of her picture surfaces are built up without rubbing or excessive piling up of chalk which is always applied as thinly as

possible so that, as in watercolor, the paper itself may play some part in the effect.

There is considerable flexibility in the medium; parts of the picture can readily be wiped out with a rag and the detail reconstructed. But every such treatment reduces the freshness of the work and a new start on a fresh piece of paper is more practical if one gets into any real difficulty.

Perhaps the chief reason why pastels are not in more general favor is the fact that their life is precarious unless they are handled with extreme care. The chalks do not have the cohesion of oil pigments and a chance rubbing may well do great damage to a picture. To offset this disadvantage pastels promise even greater permanence than oils, being free from oils and varnishes which cause paintings to darken, grow yellow and crack. Once pastels are properly

GLADYS ROCKMORE DAVIS
PAINTS A PASTEL

*The three reproductions on this page present a record of proce-
dure in the painting of a pastel portrait. The finished picture is
reproduced in halftone on the page opposite. Below, Mrs. Davis is
securing her paper to a drawing board by means of scotch tape*

Monroe Carrington photos

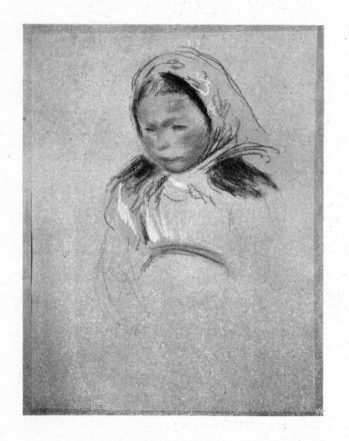

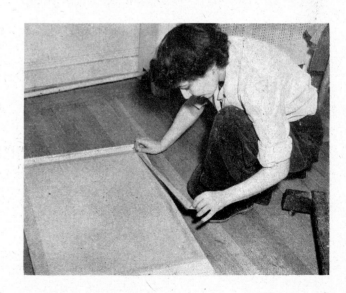

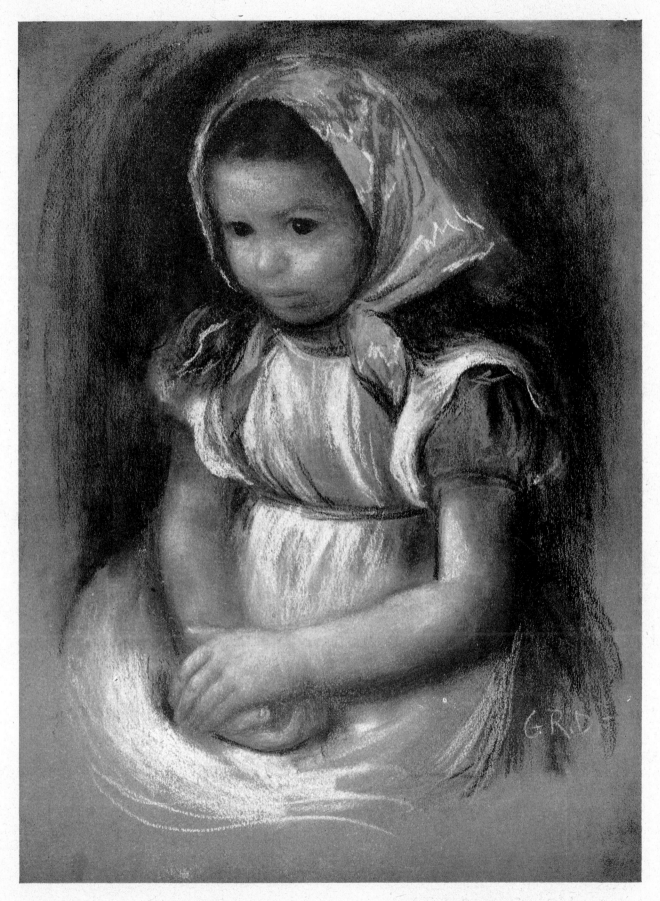

PASTEL PORTRAIT BY GLADYS ROCKMORE DAVIS

The painting was done on a warm gray paper, 20x28 inches

NOEL — PASTEL

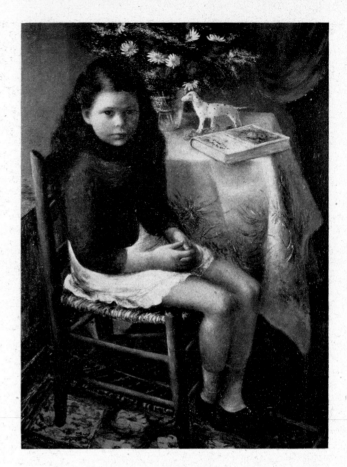

DEBORAH — OIL

DEBORAH AND NOEL
IN REAL LIFE

REPRODUCTIONS OF ALL
PASTELS AND PAINTINGS
BY COURTESY
MIDTOWN GALLERIES

Two of several pencil drawings made as composition studies for the oil painting, "Emma." This is the only kind of preliminary study (on paper) that precedes Mrs. Davis' direct painting either in pastel or oil

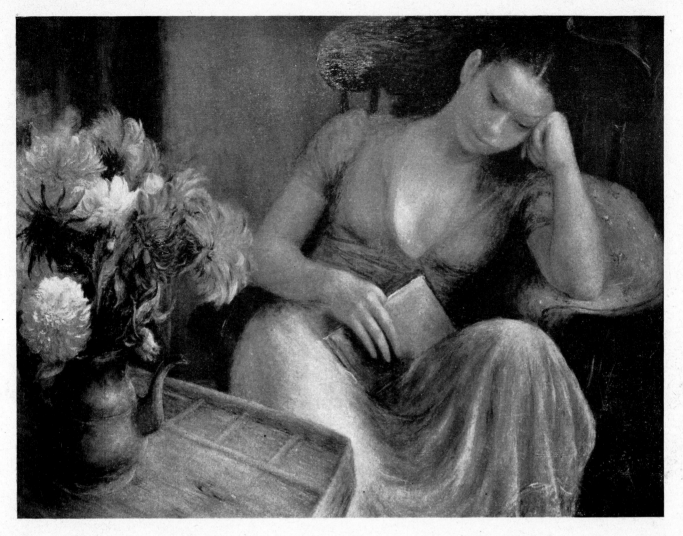

AUGUST AFTERNOON — OIL PAINTING BY GLADYS ROCKMORE DAVIS

framed they will retain their original bloom indefinitely, as pastels painted two centuries ago have done.

As soon as Mrs. Davis completes a picture she covers it with cellophane to protect it until it is put safely behind glass by the framer. A little chalk dusts off on the cellophane but not enough to injure the surface. As a matter of fact it is advisable to tap the pastel gently on its back to free it of superflous dust which might otherwise drop off the picture after it is in the frame.

The use of fixatif to prevent the rubbing of pastel is highly unsatisfactory; in fact it will spoil the picture, darkening the tones and destroying the bloom which is one of its principal charms. However, a moderate use of fixatif, while the picture is in progress, may be desirable. For example, Mrs. Davis sprays the picture slightly when it has reached a condition comparable to the second state in the series shown here. This "sets" the chalk somewhat, making it more receptive to further applications of pigment.

There are special pastel papers prepared with pumice or other abrasives intended to attract and hold the chalk. Mrs. Davis doesn't like these — few professionals do—but uses a heavy, tinted paper, hard-surfaced but with sufficient tooth to take the chalk. Paper is a most important factor in pastel work and every artist experiments to discover the surface best suited to his individual needs.

Mrs. Davis conceives her pictures in color and mass rather than in line. This observation may seem to be refuted by the pencil drawings in line which represent her only preliminary studies on paper. But these drawings only serve the purpose of composition study, of searching for the right pose. That once established, she begins the massing of colors and tones after lightly indicating, in line, the placing of the figures. Having quite completely conceived the composition before starting, she works all over the picture at once until it is completed.

As might be expected, Mrs. Davis uses her children Deborah (Sissy) and Noel (Tuffy) for models. They are the subjects of some of her best pictures. The many paintings of nudes and semi-nudes testify to her love of painting "flesh infused with the glow of life."

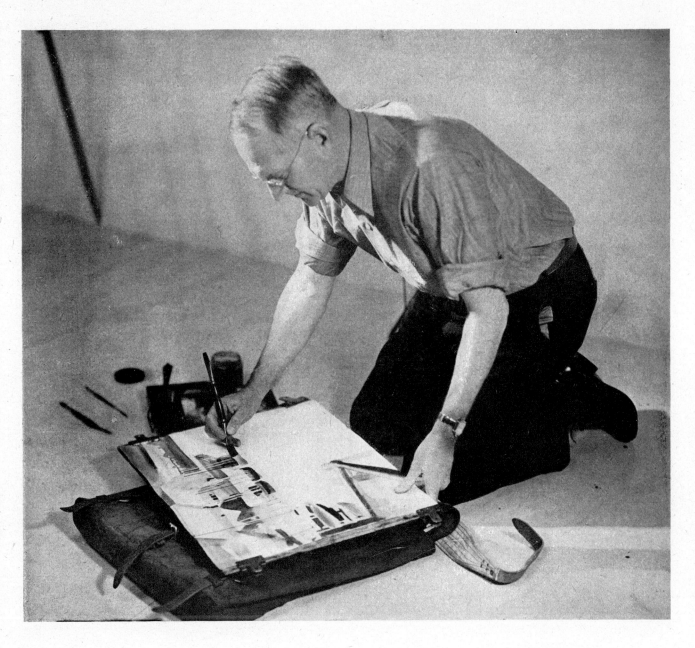

ELIOT O'HARA

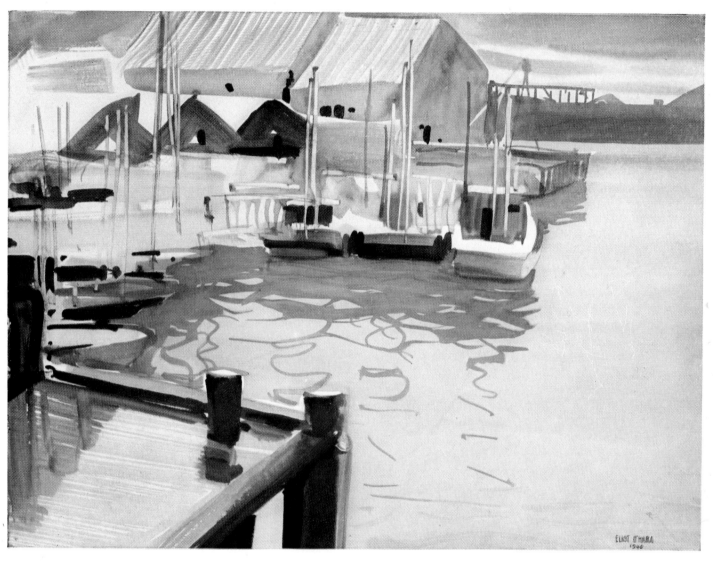

FISHING FLEET, JUNEAU, ALASKA——WATERCOLOR BY ELIOT O'HARA

To demonstrate his painting methods Eliot O'Hara made a duplicate of this watercolor. A step-by-step photographic record of his procedure is found on the following pages.

Eliot O'Hara

ELIOT O'HARA paints fast. Although he may plan a watercolor over a period of weeks, he seldom allows more than an hour for actual painting time. "Your greatest enthusiasm," he will tell you, "is felt during those vital moments of your first attack. And your brush will respond accordingly. Your most personal expression comes with your keenest reaction to your subject. The more quickly you can record your impression the fresher and more effective it will be. And remember it's the last stroke that spoils the picture."

The student, looking over O'Hara's shoulder, knows of course that such technical mastery can be achieved only through long continued practice. But he will be aware, as he inspects the artist's equipment, that the proper tools and their efficient employment have a lot to do with it too. (Page 42)

That big flat varnish brush—two inches wide—is in O'Hara's hand a good bit of the time. A few strokes with it will cover a considerable area of sky and water. Then come the one-inch and one-half-inch flat sables. It is marvelous what he does with them; dragging them over the picture with the full length of hair lying on the paper; then in an almost vertical position, stroking with the thin edge, touching with just a corner. Rapid strokes give effects differing from those with slow strokes. Learning what a given brush will do for you is one of the first steps in learning to paint, as O'Hara effectively demonstrates in his book, *Making the Brush Behave.**

Another brush in frequent use is a round sable (about No. 12), the one paired up with the knife. And that knife, by the way, is an amazingly useful tool, as is shown in the demonstration. The small brush is a No. 5 sable and the long-haired sable paired with it is a sign painter's "high liner," better known to artists as a "rigger."

That idea of attaching two brushes to a single handle is part of O'Hara's organization for rapid performance.

A list of O'Hara's tools would not be complete without mention of his fingers. They do some things for him better than brushes. In painting a tree, for example, he will brush in a foliage mass, then, with a fingernail, dip into the drip of the wash as it settles in a puddle and lead it down to form small branches connecting foliage with trunk or larger branches.

The man has a hundred resources—call them tricks if you will—which you will have to learn from his books or, if you are fortunate enough, through studying with him in person.

As a teacher, however, he deplores over-emphasis on mere manipulation of brush

*Minton, Balch & Co.

and paint; since he contends that technics are mere means to an end and can be taught or learned as easily as the alphabet or spelling. The development of the creative and the critical faculty is the important and difficult mutual problem for the teacher and the student.

Perhaps the thing that surprises one most is O'Hara's palette and how he uses it. The compartments on one side are occupied with the standard saturated colors and those opposite with the six colors comprising the "O'Hara Neutralized Spectrum"—more about these later on. The compartments are kept well-filled with pigment, carried over from day to day. Some of the pigment on the palette may have been squeezed from the tube weeks earlier. During a painting season the pigments do not dry hard from day to day and even after an interim of several weeks it is necessary to wet them only when about ready for work.

On that palette note the very restricted free area left for mixing colors with the brush. It is hard to believe that from this small space O'Hara can paint a complete watercolor without once cleaning his palette. As a matter of fact he uses no paint cloth or sponge. He squeezes excess water from his brushes between thumb and fingers.

Water, he uses sparingly. Some painters have their palettes running with wet washes. O'Hara seems to use the minimum amount of water required to float the pigment, and does a great deal of the mixing actually on the watercolor itself. He never has an excess left in his palette. To know that a pint jar of water serves for an entire painting gives more than a hint of his method of handling color. The photograph of the palette, by the way, was made after the finish of his demonstration, and without cleaning. It looks exactly as it did before he started.

Until recently, O'Hara, like most watercolorists, has used only imported hand-made papers having a rough surface. Now he often paints on a 4-ply medium surface American paper or a smooth surface illustration board. This is heavy enough not to buckle and so does not require stretching. We cannot yet expect to see satisfactory substitutes for imported rough papers made in America. Their manufacture has been handed down from generation to generation and it is not a craft that can be learned quickly.

"Two of the chief advantages in smooth paper," says O'Hara, "are the subtlety or the brilliance of the colors shown on it. The chief reason for this is that the light falls on a framed or matted picture either from the top or from one side. With rough-grained paper each lump, therefore, has a

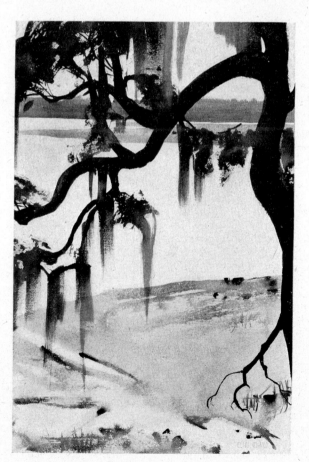

Live Oak and Spanish Moss *By Eliot O'Hara*

41

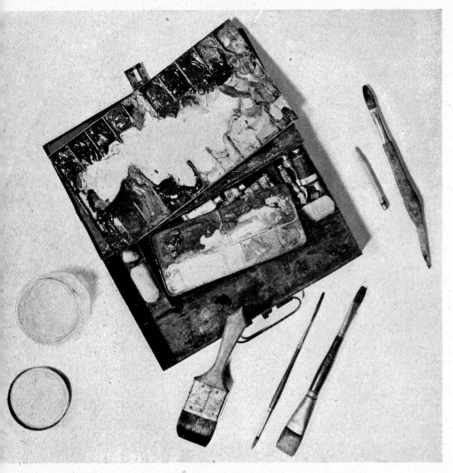

Eliot O'Hara's palette is about 6 x 12 inches. The diagram above itemizes the colors. The small palette is used for mixing grays made with black and white

lighted side and a shaded side and sometimes even a cast shadow. You see the rough-paper picture, then, not in all its clarity of color as you do the smooth-paper picture, but you descry it as through a stippled screen of false light and shadow points."

The photograph on page 37 shows O'Hara in a characteristic painting pose. It was taken in a studio, since an outdoor picture was not feasible in late October in New York City. Outdoors he would be wearing a hat and would be painting in the shade. Sometimes he sits on a folding camp stool, but he never uses an easel. He wants his paper horizontal, or nearly so, although at times he tilts it this way and that to control the run of washes.

And now let us learn from Mr. O'Hara about his Neutralized Spectrum as he himself describes it.

The O'Hara Neutralized Spectrum

"For a time after the accidental discovery of finnan haddie in Scotland, fish houses of willow wood were burned down to produce the rare flavor that the willow smoke gave to the dried haddock. Soon, however, native thrift caused the Scotch to try a less lavish method. In the field of art similar shortcuts have gradually evolved. No longer does roasted earth from Sienna produce the only 'burned sienna.' Modern chemistry now artificially manufactures iron oxides and hydroxides to make pigments even better than the primitive colors.

"It is mostly habit which makes the painter still use earths (raw and burnt), the juice of the squid, and similar extractions just as they are found in nature rather than combine them with other natural or artificial colors which might more exactly suit his needs.

"What are the needs of the watercolorists as concern pigments? Permanence is certainly one of the most important. To have a picture, upon exposure to light, turn into another picture not as good is damaging to

the artist. Moreover, it harms the art of watercolor painting as much as crackling paint and blackening color harms the art of oil painting. The making of permanent pigments is the province of the manufacturing chemist or color man. While he may also make non-permanent pigments for certain purposes, they are usually designated as such and the artist does not need to buy them.

"Next to permanence the artist desires brilliancy. Here giant strides have been made recently, not only in improving old formulae but in devising new ones. Alizarin colors have become more permanent. New replacing colors have been developed such as thalocyanine for prussian blue and a mixture of thalocyanine with a permanent yellow to replace Hooker's green. Manganese blue and alizarin orange are new colors. It is easy now to choose a brilliant spectrum of true colors which will mix well together. Not only one such set but many could be devised to suit any painter's prior habits or his affection for some pet color.

"My brilliant palette is chosen for permanence, brilliancy and tinting strength and, for obvious reasons, favors the pigment primaries: red, yellow and blue.

"While the brilliant colors—by their nature—are unmistakably of a certain hue, this is not true of the dull or neutralized ones. In neutralization the point where the painter most wants accuracy is the point where it is most difficult to distinguish one hue from another. Here a slight difference in staining power or tinting strength may cost the artist enough time to miss a drying period. His hand should be able to pick up two complements quickly and know that they will neutralize to absolute gray. But what do we find? We find a lot of brownish colors composed of various earths, and special purpose colors made by artists of the past whose problems were entirely different from ours, as to medium,

1 With his one-inch brush O'Hara began the painting in the foreground, washing in the wet dock but merely indicating the piles with light tone. Later, when painting the water, he could run the wash right over the piles, and darken the piles after the water areas dried

2 O'Hara organizes his procedure so that the strokes most likely to go wrong will be applied first. If they don't "come off" a new paper can be started with little time lost. In this subject the confused area of boats with buildings beyond was the most difficult, so was painted at the beginning, and that mass — all of the upper left corner — had to be done in one drying period (6 or 7 minutes) because he planned to scrape out the light masts before the background colors dried. The corrugated iron roofs were rendered with the flat one-inch brush, its hairs separated by squashing them into the palm of the hand

1

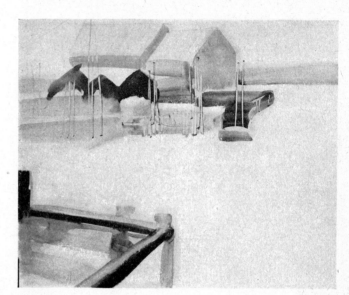

purpose and intent. Van Dyke brown, Payne's gray, Davies' gray, Mars orange — all of them dulled colors, whether made with earth or animal matter—find their place in the spectrum by accident or through the needs of some master of the past. For years I have used them, learning my own tricks of mixing them. Meanwhile, I have wondered vaguely why nobody had organized these low-key colors on an orderly basis.

"In 1940 I discovered why the color men had never armed us for the subtle quick mixing so necessary to the watercolorist. The answer was simple: they had never been asked. I had the temerity to suggest that one of the manufacturers put up in tubes a series of spectrum neutrals such as I had been mixing from various existing pigments. To use with my brilliant colors, I requested this from the chemist:

"A series of neutrals—red, orange, yellow, green, blue and violet—which must have the following qualities:

1. Absolute permanence in all mixtures.

2. Permanence to light.

3. Equal saturation.

4. Equal staining power.

5. A constant point in the spectrum for each color in all values.

6. Immediate and absolute production of gray, when complements are mixed.

"The colors were manufactured for me by a leading paint company and are, perhaps, being projected by other color firms."

3 This close-up shows O'Hara scraping the masts out of the background colors while they are still wet. The knife does not dig into the paper; it squeezes the color from the surface

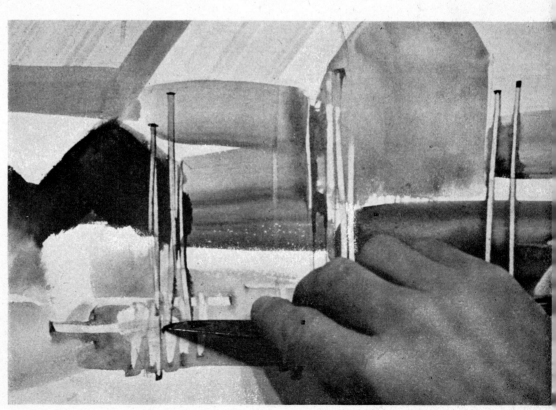

3

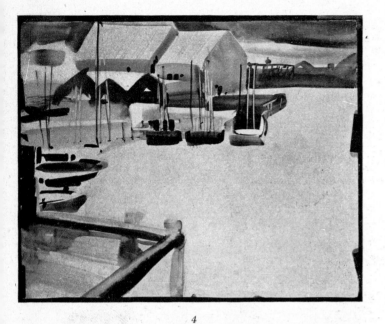

4

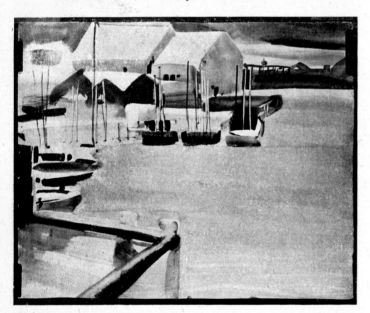

5

4 *Before painting the sky O'Hara moistened the areas (with a broad brush dipped in clear water) so that the purple cloud masses would flow on with proper distribution. While waiting for the sky to dry he brushed in the browns and blacks of the boats. Testing it with his finger, he waited until the sky had dried enough to give a relatively hard edge to the distant silhouette. The trestle, painted next, is nearer and the contour is expressed by a harder edge painted when the sky had dried out more. The order of application is determined by the drying*

5 *With the two-inch brush merely wet with water from the jar O'Hara now dampened the entire surface of the water area, letting it overlap the distant silhouette in order to give a soft edge for the transition. The color was then flooded on with the two-inch brush and the board tipped slightly to permit the wash to run somewhat. The light wave-lines in the foreground were picked out with the rigger, slightly moistened with water*

6 *The water area was dry when the boat reflections were painted with the one-half-inch brush*

7 *All that remained to be done was to darken the piles and reflections in the foreground dock*

"Here are some of the advantages of the Neutralized Spectrum:

1. For the average student they force restraint.
2. For the expert they speed the quick mixture of grays. and facilitate subtle color relationships.
3. They replace uncertain trial mixtures.
4. They make a good prescription palette for those who have difficulty in differentiating red from green. Of these there are more, even among successful artists, than most people realize.
5. They eliminate actual black from the palette; as any one of the six taken pure will count as black, but will have its own spectral flavor.
6. They provide dilutants for the corresponding brilliant colors, quickly and surely.
7. When used alone, they force the student, by denying him the use of full color, to achieve better values.

"While the three neutralized primaries, red, yellow and blue, are, of course, the important pigments, the other three (secondaries) provide complements for each of the former and the quick pick-up so necessary to the water-color painter."

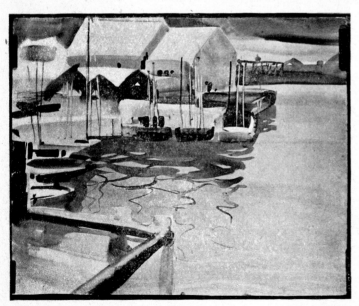

6

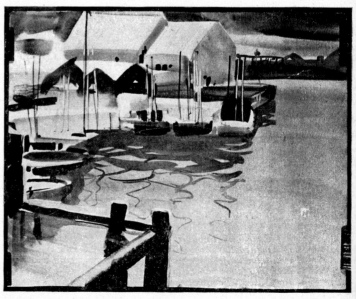

7

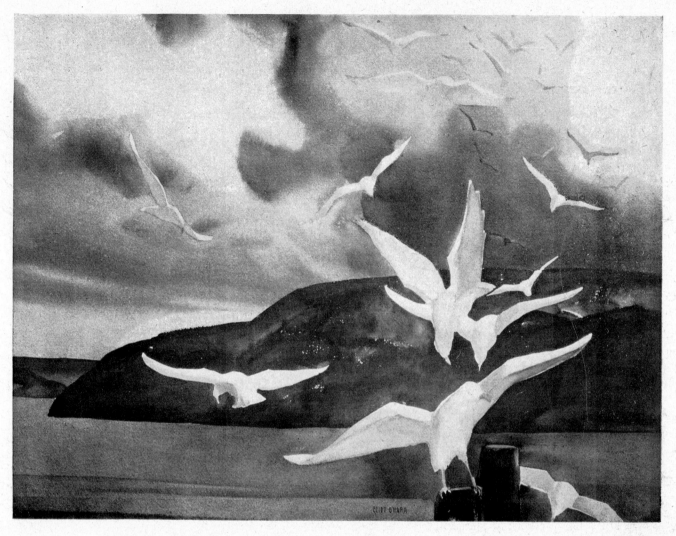

GULLS, BIDDEFORD POOL — WATERCOLOR BY ELIOT O'HARA

Collection of Joslyn Memorial, Omaha

While most artists start their careers before they are twenty, Eliot O'Hara painted his first picture at thirty-five, and so has had to make up for lost time. It is possible, however, that this lateness brought him an advantage; since he began seriously studying art only after new and vigorous points of view had replaced the more literal approach that hung on into the 1920's.

During the seventeen years after he had succeeded his father as manager of an enamel factory in Waltham, Massachusetts, O'Hara was among the first to provide group insurance and free medical care for his employees, and to offer scholarships for their children in business school or college.

Like many other artists, he showed his creative spirit early in inventions; and had taken out fourteen patents before 1928.

In that year came the two turning points in his life: the sale of the factory and the winning of a John Simon Guggenheim Memorial Fellowship. "To promote international amity", it read. Three years in Europe with his wife, the former Shirley Putnam, and their son and daughter, broadened his international sympathies; and they also proved to Eliot O'Hara that he was at last following his own special star.

His earliest exhibitions in Boston in 1929 and 1930 sold out. He showed successfully twice in London. Painting trips included the whole summer of 1929 in the Soviet Union, where he held an exhibition, by invitation, in Tiflis. Spain was the last country visited before his return to America in 1930. (Two of his Spanish watercolors are in the Hispanic Museum, New York City.)

The choice of Labrador as a sequel to Spain—the thin northern sunlight after the intense blaze of Ronda and Granada—exemplifies a resolve that O'Hara made early along the road of painting:

"Never let a manner or style become your master. Let the mood of the subject dictate the manner of its interpretation."

When a watercolor of *Louisburg Square in the Rain* was purchased at an early O'Hara exhibition and could, as the Gallery told him, have been sold twelve times over, he said:

"That's a warning—now I must avoid rainy day scenes for the next year and try as many different subjects as possible."

This resolve to cultivate elasticity of expression has produced a whole series of "O'Hara styles." First, detailed interpretation with brilliant color; second, broad washes with complete elimination of detail, (the most widely imitated of his styles); third, stress on design, surface textures and selective color; fourth, greater use of wet transitions and more subtle color.

In 1932, when his Watercolor Gallery at Goose Rocks Beach, Maine, opened its first Annual Invited Exhibi-

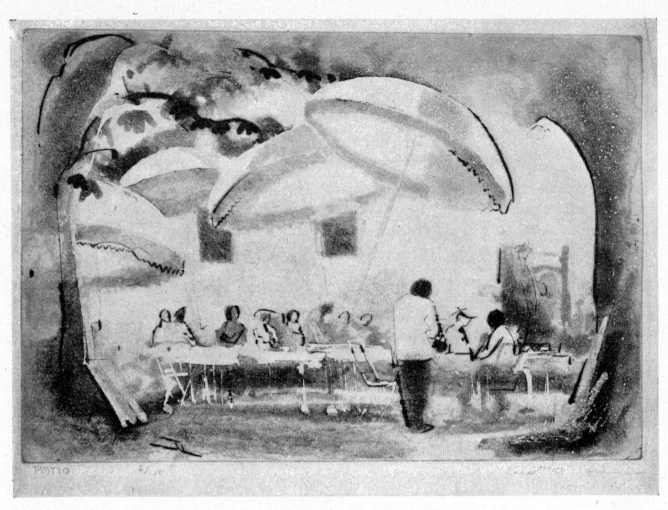

PATIO — AQUATINT BY ELIOT O'HARA

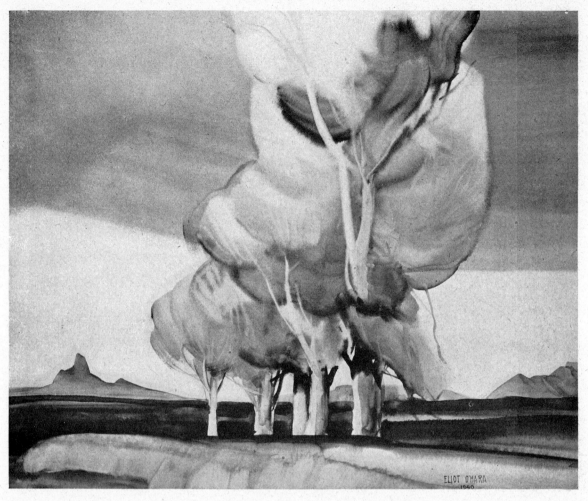

PICACHO AND COTTONWOODS — WATERCOLOR BY ELIOT O'HARA

Collection of Dr. William E. Murphy

tion, O'Hara initiated the practice of hanging in the same show conservative watercolors with radical ones, all painted in styles as divergent as possible. (He resents the fetish for cleaving art into "modern" and "conservative"—all contemporary art *is* " modern".) During the past ten years the paintings of over 300 distinguished American watercolorists have been shown in this Gallery to visitors numbering over 10,000 a summer.

Variety of expression, implemented with a hard-earned facility in technic, is what he seeks to impart to the students at his school in Maine. A student jury system which passes on each day's particular problem, as well as study of the Invited Exhibition, helps to emphasize the importance of developing the critical faculty.

Eliot O'Hara's teaching methods—all based on the belief that while technic *can* be taught, expression and creation must come from within each individual—have found many outlets. Besides having had schools in Maine, Washington and Arizona, he has also given courses in other art schools at the Telfair Academy, Savannah; the University of North Carolina; the Yale School of Fine Arts; the John Herron School, Indianapolis; the Philadelphia Museum School of Industrial Art; and the Norton School of Art, West Palm Beach.

As for Eliot O'Hara's own watercolors, his one-man exhibitions have been shown, by invitation, in practically every important center of art in the United States. Among special collections have been his series painted in the Soviet Union, his *Trees in Watercolor* and two entitled *The Hemisphere in Watercolor.* Of the last group many were painted during a winter in South America; others range from Labrador in 1930 to Hawaii and Alaska ten years later.

His pictures have won a number of awards and twenty-six have been acquired by public collections.

After one year of intensive work in a new medium, etching, he had won prizes for his aquatints.

Five reels of motion pictures of O'Hara painting in watercolor, taken by the University of Indiana, are in constant circulation, through the Extension Division of the University.

His four books—*Making Watercolor Behave, Making the Brush Behave, Watercolor Fares Forth* and *Art Teachers' Primer,* published by Minton, Balch & Co., are further revelations of the mind of an artist who rejoices in exploring the varieties of his own means of expression, as well as the far reaches of mood in design or in nature.

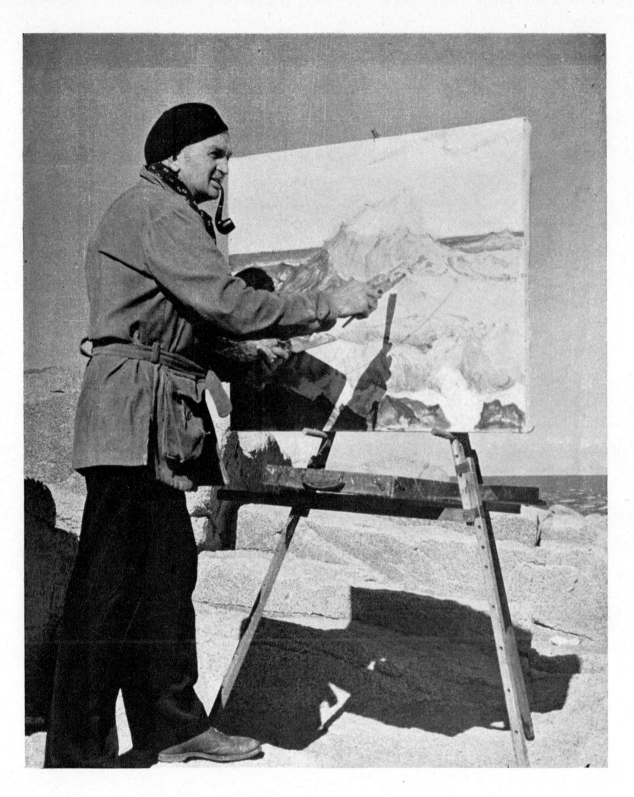

STANLEY WOODWARD

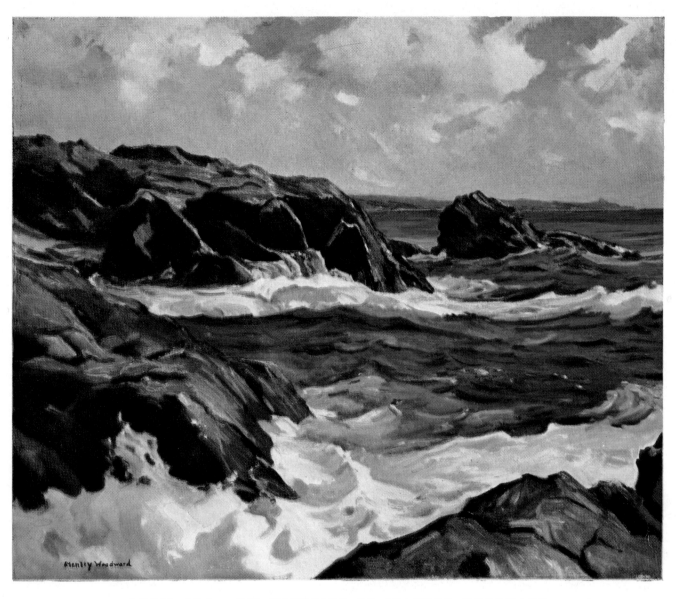

APRIL SEA——OIL PAINTING BY STANLEY WOODWARD

Courtesy Grand Central Art Galleries

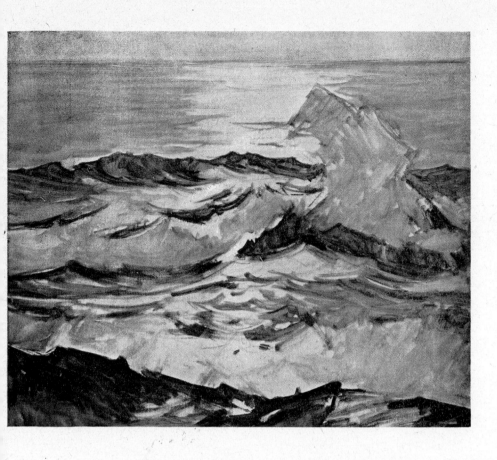

THE LAY-IN
FOR THE CANVAS
"SILVERY RAYS"

SILVERY RAYS
BY
STANLEY
WOODWARD

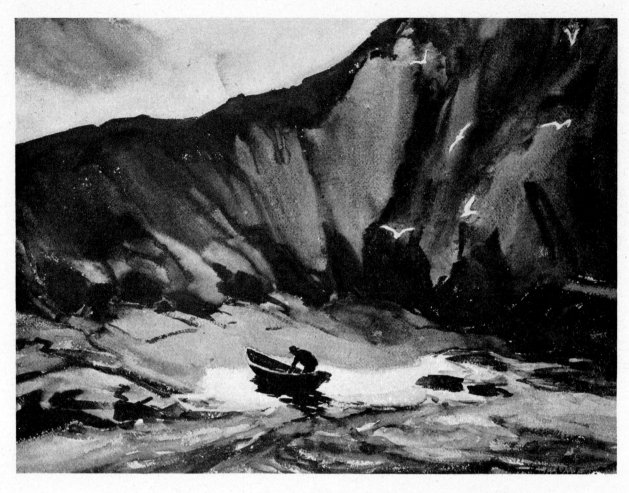

DAYS END — WATERCOLOR BY STANLEY WOODWARD

Courtesy Grand Central Art Galleries

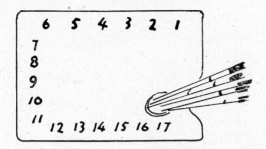

STANLEY WOODWARD'S PALETTE

1 Zinc White	7 Raw Sienna	13 Cobalt Blue
2 Zinc Yellow	8 Burnt Umber	14 Manganese
3 Cad. Yellow, med.	9 Burnt Sienna	15 Ultramarine
4 Cad. Orange	10 Rose Madder	16 Indian Red
5 Cad. Red, lightest	11 Aliz. Crimson	17 Black
6 Yellow Ochre	12 Viridian	

I like zinc white best, and am satisfied that a 50% mixture of oil and turpentine is as good a medium as any.

"I nearly always prepare my own ground, giving my 12x16 mounted canvas an extra coat of zinc white—I dislike an absorbent surface. Sometimes I experiment by staining the surface with a warm tone, usually a mixture of raw sienna and umber thinned with plenty of turpentine. After allowing it to dry a few minutes I wipe it off with a cloth. For certain subjects it provides a beautiful color into which to paint."

Stanley Woodward is best known for his New England marines and old houses—more about these presently—but he by no means confines his painting to the cold color of northern latitudes. To stimulate a somewhat under-nourished palette, after months of painting on the Coast and in the hills of New England, he journeys to warmer and more colorful regions. A few months of painting in Bermuda, Florida, Porto Rico or California revitalizes his color which, he fears, might become too gray if he worked constantly in the rather bleak climate farther north. He travels to these places by boat, naturally enough, and the days spent on deck, in fair weather and foul, have been a part of his education in the behavior of the sea.

But Woodward is at his best in New England. Perhaps this is because the Woodwards have lived in and around Boston for twelve generations. He has a definite sense of belonging, of being a link in the Colonial tradition. That may account for his nostalgic interest in old New England farmhouses which reach back into a past with which he feels identified. These gray relics of a more prosperous day on New England's farms have been drawn and painted by Woodward for many winters and summers. Although they are somewhat eclipsed by the popularity of his marines they are indeed characteristic "Woodwards."

"My interest in old New England houses," says Woodward, "is an early one; it dates back to days when I worked only in pencil and pen and ink. My first exhibition was a group of drawings of Marblehead. Old weatherbeaten houses—the older the better—make ideal subjects for the lead pencil. Their charm

is a certain intimacy the artist attains by reason of the enforced attention to details. Probably this early training has influenced my approach to the same subject as a painter.

"Now, as then, I stand close to my subject where I can see the stocking stuffed in the broken windowpane, the sagging steps, the woodshed in the rear, the once-red paint bleached to a lovely gray-pink. Here is a glimpse into the past; a past that extends into the very present. These old houses become as much a part of the surrounding landscape as the hills and skies themselves.

"The evolution of my picture, *Storm over Lanesville*, from its first beginnings demonstrates the many stages involved before completion of the large canvas.

"I first made a detailed pencil drawing of the building, when out one day with some pupils. It's a place on Cape Ann that I know well, having seen it from the road on many occasions and under a variety of conditions. Later I made a 12x16 oil sketch on a sunny day. This served well enough as a factual record but it lacked any distinctive mood or interpretation. However, the placing of the central motive and the general composition of the canvas were fixed. Weeks later, quite by accident, I was riding by as a storm approached behind the barn. I said, 'That's it! It should be painted in a storm!' When I got back to the studio I at once—while the impression remained vivid—made a watercolor, showing dark clouds overhead, the livid water and a general sense of stark isolation.

"I had my pencil drawing and sunny day oil sketch for reference as to details and composition. My watercolor had added the true color scheme and set the mood. I was all ready now for the large canvas, but it was not until several months later that an opportunity arrived for the final painting."

In the summer students flock to Woodward's classes in Rockport, Massachusetts. And no wonder; Woodward knows how to teach as well as to paint. He is enthusiastic and has a natural out-giving personality.

Summer classes over, he is off to the hills for several weeks' painting in Maine, New Hampshire or Vermont. His love for the mountains of New England is responsible for some very fine canvases.

Stanley Woodward was born in Malden, Massachusetts, in 1890, and received his art training in neighboring Boston, first at Eric Pape Art School, then the School of the Museum of Fine Arts. Later he went to Pennsylvania Academy. After two years in the Army (World War I) he settled in Ogunquit, Maine, where, he declares, he found the finest marine subjects on the Coast and was captivated by them. His paintings of the sea found buyers and he continued to paint in Ogunquit for thirteen summers. Then he moved down the Coast to Rockport, where he now has his home.

Woodward has won many coveted painting prizes and he is well represented in our museums and in private collections.

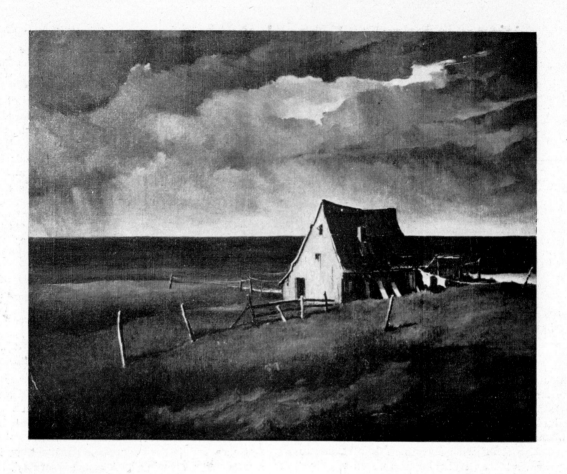

STORM OVER LANESVILLE

OIL PAINTING BY

STANLEY WOODWARD

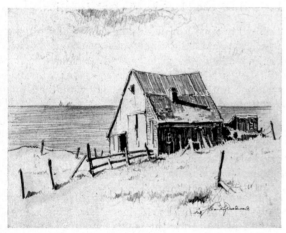

This picture started with the pencil sketch made one day while out with a painting class in Lanesville, Mass. The old barn perched upon a hill overlooking the sea interested Woodward, but it was not until he saw it against a stormy sky— months later—that the subject assumed dramatic value and aroused a desire to paint it. The oil sketch (below), done on a sunny day, and a watercolor study of the storm brewing were made before the large canvas (40x50) was begun

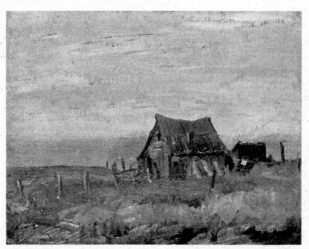

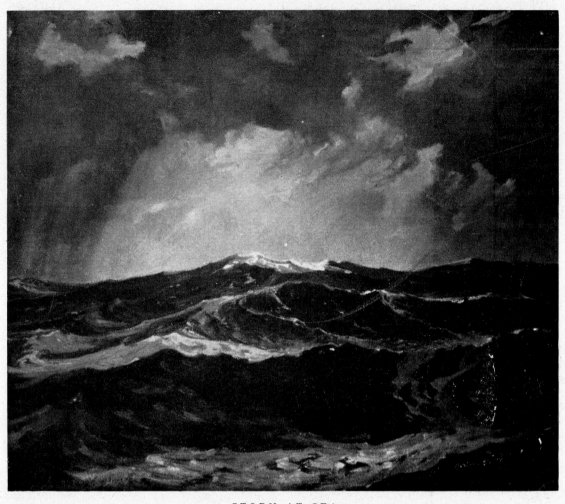

STORM AT SEA

OIL PAINTINGS BY STANLEY WOODWARD

THE CHALLENGE

ANDREW WYETH

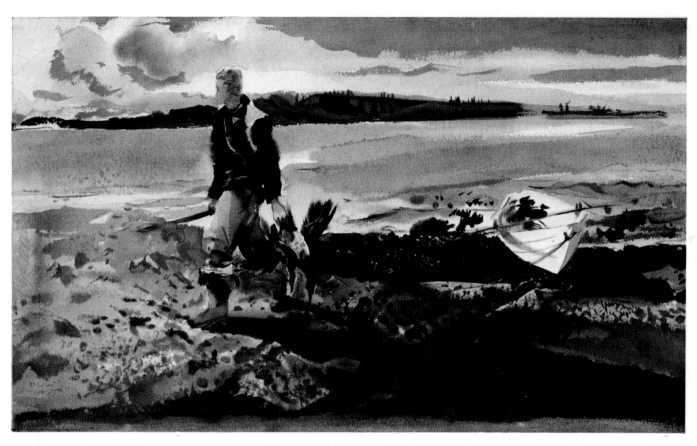

COOT HUNTER——WATERCOLOR BY ANDREW WYETH

All reproductions by courtesy Macbeth Gallery

One of America's Youngest and Most Talented Painters

Andrew Wyeth

Andrew Wyeth's watercolors are exuberant. They dance, they sparkle, they are full of the gusto with which this young artist embraces nature and life itself. They are likeable. So is Wyeth who, when he enters, brings into the room something of that breezy quality that makes his pictures so pleasantly active; and something too that impels you to call him "Andy" at the first meeting.

What young Wyeth has accomplished in a few brief years has been quite extraordinary. From the very first he seems to have been marked for success. Now, at the age of 25, he has sold 125 watercolors and has had 15 one-man shows since the first, which was held at Macbeth's just after he had turned 20. In that first show every picture was sold; in the second all but one. Today his watercolors hang in nine art museums and are in many private collections. He is among the few who are able to devote themselves exclusively to their painting.

Wyeth's success has indeed been phenomenal, but it has not gone to his head. While recognizing his possibilities he knows that his feet are on the lower rungs of the ladder. He realizes too how easy it is to fall off a ladder; and is working hard and intelligently to build a sound foundation for what he hopes to do in the future. He knows that, even if he wanted to, he could not skate along indefinitely on his present popularity. As a matter of fact he is far less concerned about that than about his growth as an artist.

While Andrew Wyeth can thank no one but the gods for the talent with which he has been endowed, he can and does give much credit to his famous father, N. C. Wyeth, for what he has done with it. He grew up in his father's studio in Chadds Ford, Pennsylvania, and now lives, literally and figuratively, at his father's feet, down over the hill from the parental estate in the beautiful Brandywine Valley. Father and son continue in that happy and mutually profitable companionship that began when N. C. set little Andy down to draw, in a corner of his studio.

The curriculum in that informal school was simple, sound and unsweetened. Drawing from casts and learning to represent the appearance of ordinary objects and nature with strict fidelity was the basis of this early instruction. There was painting out of doors as a matter of course. So far as "art" was concerned the father left that pretty much to its own germination and to whatever influence the boy might extract from his environment. Andrew is glad to remain under that influence today. The fact that the work of the two men has little in common—externally —gives assurance that the influence is thoroughly wholesome.

In discussing influences we should not overlook the importance of growing up in a family whose members really constitute an artists' colony. The Wyeths are America's largest-sized painting family. Besides father Wyeth and Andy, there are sisters Henrietta and Caroline, both painters; and sister Ann, whose symphony was performed by the Philadelphia Orchestra, Stokowski conducting, before she was 20. Henrietta married Peter Hurd, famous painter of New Mexico. Ann is the wife of John McCoy, a young painter residing in Chadds Ford. Brother Nathaniel is an inventive engineer. It is not difficult to imagine the atmosphere engendered by a family like that.

Talk about life and art must have mingled with every menu and colored even the most casual conversation. Andy has further strengthened the art potential of the family, marrying Betsy Merle James, also an artist, whom he met on her father's farm in Cushing on the Georges River, Maine. She is high spirited and very sensitive to the aspiration of her husband. She embodies that rare combination of enthusiasms, love of home and love of the out of doors.

"In cataloging these home influences," remarked Andy, "please do not omit the predominant importance of a mother whose love and energy have, over the years, supplied a rich background of domestic completeness incalculable to an artistic family."

Since Andy was two years old the Wyeths have spent their summers at Port Clyde, a little fishing village on the northern coastline of Maine. Here he played around the waterfront with the fishermen's lads, and later began his painting career.

He did his first professional work at the age of 12: a decorative pen and ink heading and tail piece for a preface his father wrote for Howard Pyle's *Merry Adventures of Robin Hood*, published by Scribners. He has illustrated many books since, the latest being *The Brandywine* by Henry Seidel Canby, of the well known river series published by Farrar & Reinhardt.

The best way to understand Andrew Wyeth's watercolor credo is to compare almost any of his very recent pictures with one which was painted before he had come into realization of his present objective and the power to accomplish it. Take *Island Dawn* for example—a truly fine bit of painting by ordinary standards. Put it alongside *Lobster Pots*; the difference in approach is obvious. It lacks the verve, the evidence of incitement which animates the latter in every brush stroke. The mood of the early morning subject, to be sure, has something to do with this contrast but, all the same, that picture would be handled differently today. In *Lobster Pots* the artist's exhilaration has become articulate; he has really learned to use his wings.

Wyeth has a very positive feeling about watercolor. He loves it because it is sensitive, as is no other medium, to every impulse of an inspired moment. He loves it too because it is a sporty medium. You cannot exactly carry out a predetermined effect in watercolor—that is, in the fluid method. Chance enters into it no matter how skilful and experienced you may be. The paper must be precisely the right degree of dampness here, dryness there; the brush must be loaded to nicety, and a false stroke in a vital spot is irreparable. No sponging out, no laboring over weak passages; either

Pencil drawing of coots, made by Wyeth preparatory to the painting of "Coot Hunter"

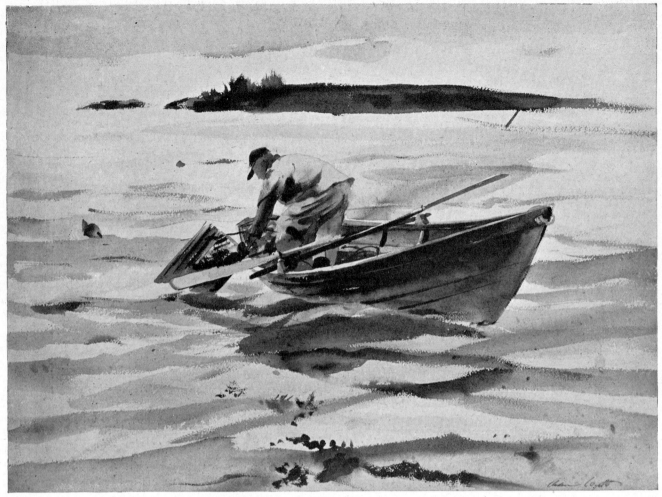

MORNING LOBSTERMAN — WATERCOLOR BY ANDREW WYETH

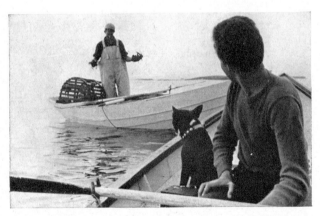

Andrew Wyeth and "Lupe," his constant companion for thirteen years, greet fisherman Walter Anderson in the harbor of Port Clyde. Anderson posed for "Coot Hunter" and "Morning Lobsterman"

it "comes off" at the first flush or the paper is cast aside and a fresh start made. So it is, says Andy, that maybe one in a dozen watercolors rings the bell. So insistent he is upon this *premier coup* method that he will often spend a morning in brush practice in order to limber-up for a picture he is eager to do in the afternoon.

Wyeth seldom spends longer than a half hour on a watercolor. But weeks may have preceded the study and the building up of the mood of that watercolor. If he knows just what he wants to do—he doesn't

begin otherwise—that is long enough, he says. Many pictures are done in less time than that, as was *Morning Lobsterman* which was done in a quarter hour. But, as usual, that picture was preceded by careful preparatory study. A fisherman friend in hip boots, standing in shallow water, held the dory in just that tipped position long enough for Andy to make a careful pencil drawing of it—he has to be authentic with his boats in order not to lose face with those Maine fishermen with whom he grew up. The boat was then drawn quite meticulously on the watercolor paper, in order to give the impulsive brush the greater freedom in painting. The fisherman posed in the boat during the entire painting period of fifteen minutes.

Many of Wyeth's pictures are painted on location, but he also does them in his studio after much study of the subject in nature. Frequently he will make a rapid sketch on the spot in pencil or pen and with this note develop his watercolor in the studio.

To prepare himself for *The Road to Friendship* watercolor he even made an architectural rendering (with T-square and triangles) of the white house, carefully delineating all the details, including the ornamental scroll work over the door, and developing its correct perspective by extending converging lines to vanishing points on the eye-level. This in addition to black and white studies of the landscape.

He works on a medium rough watercolor paper which he has made up in blocks (22x30). He objects to stretched paper, says he believes it loses its capacity for brilliant effects.

All his painting is done with three sable brushes,

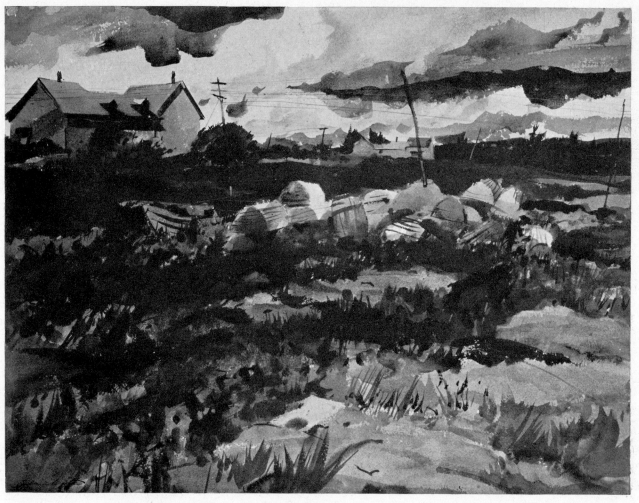

LOBSTER POTS — WATERCOLOR BY ANDREW WYETH

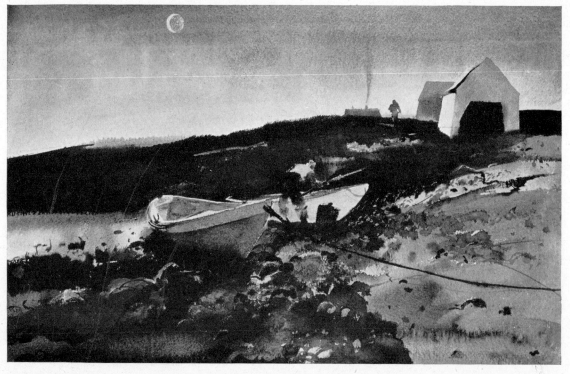

ISLAND DAWN — WATERCOLOR BY ANDREW WYETH

THE WRECK ON DOUGHNUT POINT — WATERCOLOR BY ANDREW WYETH

Nos. 5, 10 and 15. He never uses those broad flat brushes so many artists employ for large, covering washes.

In view of the gusto with which Wyeth works, one is surprised to see such a small palette in his hand, especially since in his rapid painting he must require a quantity of "runny" washes on short order.

In beginning a watercolor Wyeth very rapidly lays-in the large masses in their approximate colors, but without detail definition. This may or may not have been preceded by a slight pencil indication. Thus the paper is entirely covered in the first few moments, except for white areas which are untouched by the brush —Wyeth never uses white body color. Occasionally white, or near white, is obtained by a heavy stroke of the brush-handle in a still-wet wash. Working back into the wet areas he develops his picture, pulling definition out of the blurred color masses, working all over the picture while it is still moist.

The technic of watercolor—that is, in the fluid method—presupposes rapid and skilful execution. Yet working within the limitations of its properties some artists proceed with a degree of deliberation. It is quite possible, technically,—and without sacrificing freshness—to work on a picture over a considerable period, even to come back to it the next day. Many artists spend at least two or three hours on a picture. Wyeth's practice is to skim off the white heat of his emotion and compress it into a half hour of inspired

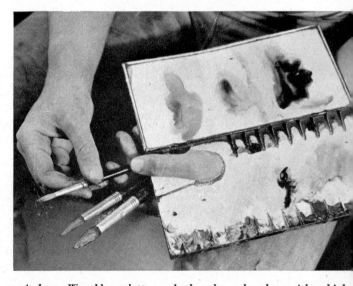

Andrew Wyeth's palette and the three brushes with which paints all his watercolors. Below: Andy painting on a rocky be

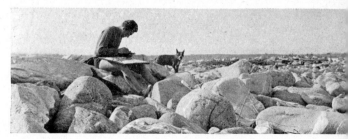

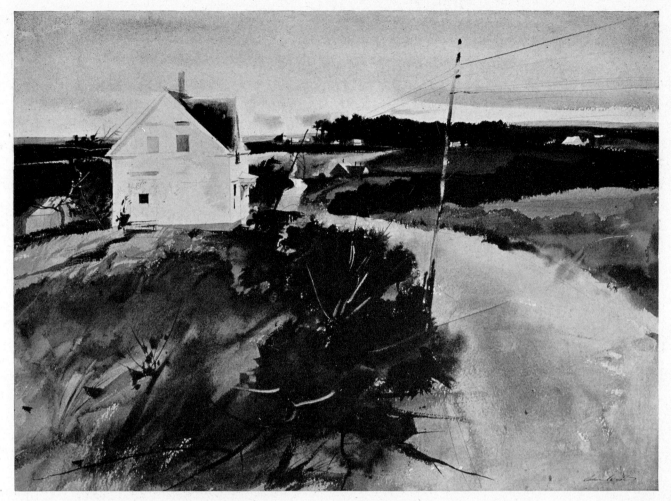

THE ROAD TO FRIENDSHIP — WATERCOLOR BY ANDREW WYETH

Wyeth often makes rapid ink sketches like this, on the spot, and then does the watercolor in his studio

Exact-size fragment of a drybrush drawing. Drybrush is one of Wyeth's favorite study mediums

brush work. He is the first to admit the presumption of this kind of attack, and is ready to confess that it fails more often than it succeeds. The supposition is, of course, that considerably more than emotion is available for use in those thirty tense minutes which might be compared to the brief moments of a surgical operation. Both operations are made possible only by a substantial reservoir of training, experience, and preparation for the particular task.

No one appreciates more completely than Wyeth the need for this background of sound training and the discipline of struggle. And he has the courage of his convictions. Mindful of the dangers inherent in practiced facility with his watercolor brushes he has put them away in moth balls for a season and, during the past year, has been devoting himself to tempera painting, employing a technic that imposes strict disciplines. In this medium he is producing pictures as meticulously imitative of nature as possible. Into them go weeks of preparatory study and weeks of careful painting. The tempera overmantle of the old buttonwood tree, for example. That picture occupied three months of preparation and painting. The drybrush study of the tree itself, an almost photographic rendering, took several days. The old house was as carefully studied in pencil and crayon drawings as were the hills beyond.

The picture, an overmantle in the home of Leonard Yerkes of Wilmington, Delaware, is an authentic por-

DRYBRUSH STUDY OF BUTTONWOOD TREE BY WYETH

This pen sketch was the very beginning of Wyeth's tempera painting of the old buttonwood

Below: Pencil drawing of the Lafayette house, (one-third actual size)

trait of the old buttonwood tree, still standing, under which the wounded Lafayette was brought during the battle of the Brandywine. The stone house beyond was used by him as his headquarters during the battle.

In his temperas Wyeth's objective is to cover up his brush strokes and obtain a sense of freedom through pattern rather than technic. He paints these pictures with a single sable brush not over ¾ of an inch long. They are done on *Masonite* upon which three coats of whiting mixed with casein glue are applied as a

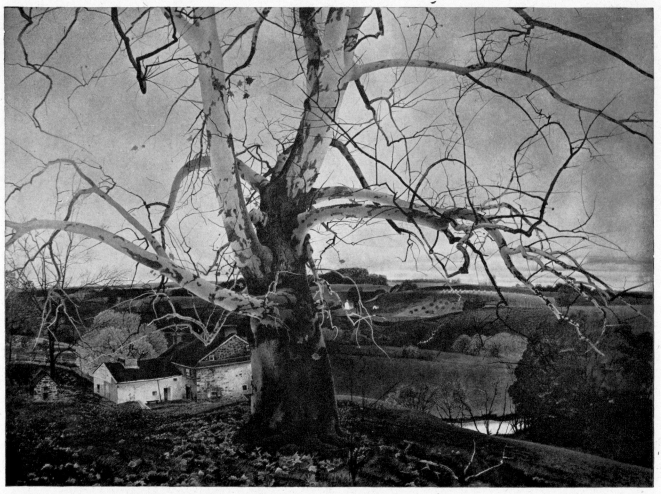

TEMPERA PAINTING BY ANDREW WYETH —— AN OVERMANTEL IN THE HOME OF LEONARD YERKES

Sanborn photo

ground. The pulverized glue is heated, in water, in a double boiler. Wyeth sandpapers the final coat to a very smooth finish. The panel is made rigid by a framework attached to the back. He paints with dry colors mixed on his palette, as he works, with distilled water and egg yolk.

His procedure is to make a monochrome underpainting in black ink. The colors, applied over this black and white, have a quality of weight and depth preferred to the result of direct painting in color. This is in accordance with the traditional method of the old masters who used this medium.

This turning from the freedom of watercolor to the exactions of tempera illustrates the intelligent purpose of a young artist in seeking strength and breadth as foundation for the work he hopes to do later on. Through his tempera paintings he is acquiring the habit of accuracy and is seeking an intimacy with nature which he feels he cannot attain with his watercolor brush alone. Thus fortified, he believes his watercolors, though painted in a burst of enthusiasm, are more likely to be informed and interesting in every detail. "Too often," he says, "a watercolor appeals solely by virtue of tricks and fortuitous beauties inherent in the medium itself. My aim is to make every part of the picture alive, interesting."

Wyeth has a deep conviction that a painter should know very intimately, and over a period of years, the landscape and subjects he presumes to interpret. He says, "I believe the artist should even be indigenous to the country which he paints. This, I know, is contrary to the practice of many presentday painters who dash about to sketch here and there."

In this connection Wyeth speaks of his friendships with the fisher-folk of the Maine Coast, among whom he has been brought up. With them he has gone dory lobstering among the many islands of the Georges Group, and through these companionships he has acquired his deep feeling for the Maine Coast.

The casual observer, turning from Andrew Wyeth's impulsive watercolors to his tempera paintings, executed in the spirit of patient old master craftsmanship, might well be puzzled. They appear in temperament as well as in technic like the work of two separate individuals. They are, in the sense that the well-rounded man is a different man at different times, as he takes devious directions to arrive at a goal that cannot be approached by a single path. Only the artist himself can see the map whereon those divergent paths finally meet in the ground strategy of a single purpose. We shall watch for the meeting of those paths in the work of Andrew Wyeth.

OGDEN M. PLEISSNER

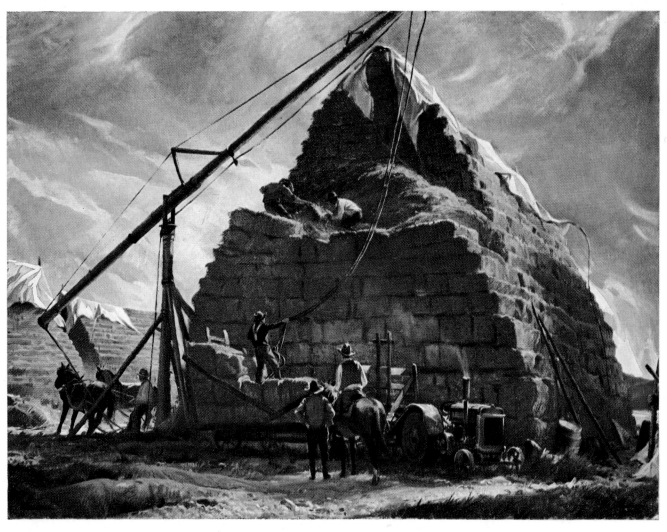

HAYSTACKS AT RAILROAD RANCH——OIL PAINTING BY OGDEN M. PLEISSNER

Courtesy Macbeth Gallery

Ogden M. Pleissner

FOR many summers it has been Ogden Pleissner's custom to journey to the West for several months of painting in the wilds and on the ranches of Wyoming and adjacent states. This dramatic country so captivated him—on his first visit—that he now establishes himself there from June to October in a log cabin a few miles from the little town of Dubois, 7,000 feet above sea level. Within easy striking distance of his cabin are many of the subjects which, through his pictures, have become familiar to admirers of his work: rugged mountain scenery, broad fields of grain, harvesting scenes on the ranches, and deserted mining towns on the Oregon Trail.

Then there are the pictures that come from the woods and streams of Quebec and New Brunswick where Pleissner is likely to be found in the spring, with salmon rod and sketching equipment. Travels through New England and the South have yielded still greater variety to the subject interest of this young painter who appears to love anything so long as it is open country.

Pleissner was born in Brooklyn in 1905, and one of the first pictures to give him prominence in the art world was a painting of a Brooklyn back yard, which was purchased by the Metropolitan Museum of Art in 1932. Since then his career has been generously dotted with honors: prizes for his oils and water-colors in the important national shows, election to the National Academy of Design, and acquisitions of his pictures by Brooklyn Museum, Toledo Museum, Minneapolis Art Institute—to mention a few.

Furthermore, and quite as important, people like Pleissner's pictures and have purchased them, thereby enabling him to devote his entire time to his painting. He is an optimist. His canvases depict the grandeur of the earth, they radiate the joy of being alive in a bounteous nature, and he paints them with conviction. This applies to laborers in the field as well as to nature herself. Here is one artist who can look upon workers without being outraged at the sight of men sweating at an honest day's toil.

All of us, even the critics, can enjoy such things. But the critics expect more, and they find it in Pleissner whom they acclaim for his craftsmanship. By training and by practice he is a thorough-going painter. He knows how to make the most of his subject through largeness of design, a strong sense of form, distinguished draftsmanship and invigorating color. All these qualities he employs in providing pictures that are realistic enough to delight nature lovers and sound enough in painting qualities to deserve the admiration of critics. At least three New York critics, commenting upon his 1941 exhibition at Macbeth's, were reminded of Winslow Homer. One of them, at the same time, classified Pleissner as a historical painter because of the accuracy with which he records many phases of the American scene. Just how he may be classified is of little interest to Pleissner. He will tell you that it is his delight in color, form and design that gives him incentive for a picture, rather than factual subject matter; although like all artists he is attracted more by some types of subjects than by others.

The collection of sketches leading up to the canvas,

OGDEN M. PLEISSNER
in his New York studio

The large mirror in the corner is constantly in use for reflecting the painting in progress. Seeing the picture in reverse gives the artist a fresh eye in judging its qualities

Alfred A. Cohn photo

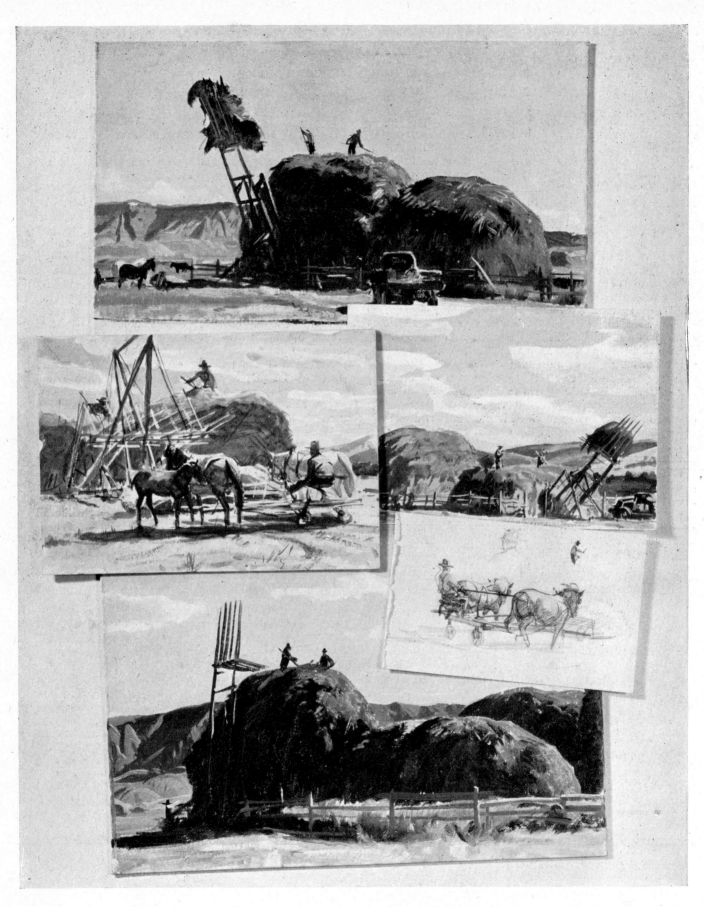

This group of sketches preceded the canvas "Stacking Alfalfa" shown on the page opposite. The top and bottom studies are oils; the two center ones are watercolors. These were all made on the spot

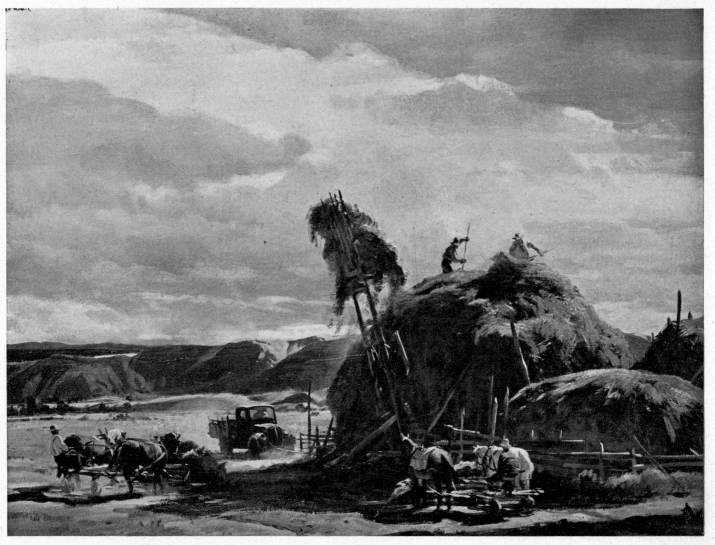

STACKING ALFALFA (20 x 24) —— OIL PAINTING BY OGDEN M. PLEISSNER

Collection of Dr. Chester J. Robertson

Stacking Alfalfa, gives considerably more than a hint of Pleissner's creative processes. Referring to them he says, "Several days were spent in the haying fields making these various studies of color and mass effect. Using these notes as factual material it was possible for me to build a composition having the spirit of brilliance and activity that so impresses me about this phase of ranch life. It so happened that these hay-stackers were close at hand, and during the time that I was working on the final canvas I could visit and study my motive at moments when the mood or effect that I wished to express was in evidence.

"Often I have many sketches closely related to the finished canvas (page 78); at other times my procedure is entirely different; my large canvas is started and nearly completed out of doors, then finished in the studio. I have also come upon subjects that excite my imagination but, at the time seen, the effect is very dull. Nevertheless I make a study, generally in color if possible, and by changing the light effect, the key, color and form organization an entirely different and interesting picture may be evolved."

Artists approach their paintings in vastly different ways, both in analysis of subject and in organization of technical procedure. Two painters come upon the same scene. The identical trees, fields and stream lie before them. What each sees through his own temperament, training and habit is quite unlike the impression made upon the other. Some react to the subject more or less intuitively, others through deduction. The former rely more upon impulse than conscious organization. The latter apply the logic of generalization to the particular effect, analyzing the subject on the basis of what might be expected under a given set of conditions. That does not necessarily imply that they paint today what they saw yesterday, that they are less responsive to accidental effects. It means that they hold those effects in control through orderly observation.

Pleissner belongs in the latter category. Before he begins to paint he carefully analyzes every aspect of the subject, form, lighting and color. He applies his knowledge of natural law to that which meets his eye. His procedure is logical, not hit or miss. Not that he never misses nor that his way is better than another! But it is his way and through it he achieves a relatively high score.

To be more specific about it, Pleissner will tell you that his observations of nature are based in part upon the most elementary geometric form, the cube. Relating irregular and complex forms to this geometric figure assists him in their definitions and in the organization of painting procedure. For example,

79

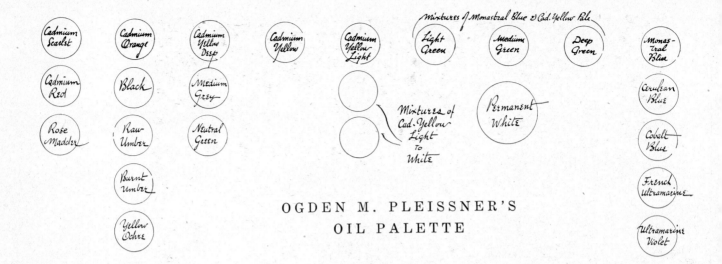

Mixtures of Monastral Blue & Cad. Yellow Pale

Cadmium Scarlet · Cadmium Orange · Cadmium Yellow Deep · Cadmium Yellow · Cadmium Yellow Light · Light Green · Medium Green · Deep Green · Monastral Blue

Cadmium Red · Black · Medium Grey · Mixtures of Cad. Yellow Light To White · Permanent White · Cerulean Blue

Rose Madder · Raw Umber · Neutral Green · Cobalt Blue

Burnt Umber · French Ultramarine

Yellow Ochre · Ultramarine Violet

OGDEN M. PLEISSNER'S OIL PALETTE

a tree with all its mass of branches, twigs and leaves still remains a simple form with top, under plane and side planes. With this fact in mind the painter may include as much detail as he may desire or simplify to the extent of starkness, but always his canvas will have a sense of solidity. In attempting to base his analysis upon this simple principle, he can sense the great progressions of color from light to shadow, warm to cool, brilliance to dullness, without being distracted by the confused masses of leaves and twigs, which, without a conception of simplified form structure, can easily befog the painter's purpose. Objects in nature have their local colors; when reduced to simple planes the vast changes in these colors, due to illuminations from many sources, are more easily understood. This is but one element in Pleissner's picture organization; however, it goes far to explain qualities which give his paintings distinction.

At first glance, Pleissner's oil palette—his watercolor palette is similar—seems to be rather complicated. In reality it is quite simple. If the colors of the outer rows were arranged in a circle, the rose madder adjoining ultramarine violet, they would fall into the proper spectral sequence on the color wheel. The earth colors, (umbers and ochres) plus black, gray and neutral green, are conveniently segregated for mixtures with any of the spectral colors.

Pleissner sets these colors out in a shallow tray (in the order shown) about 12x16 inches. His mixing is not done on this small tray, but on a porcelain-top table about 20x28 inches.

When painting in the studio it is Pleissner's practice to lay-in his picture with casein tempera, applied very thinly like watercolor. This is done in monotone—say burnt umber—or, in some cases, in hues suggestive of the oil color to be applied in the over-painting. One advantage of the tempera underpainting is its great flexibility: changes can be readily made by sponging out and re-drawing. The tempera dries quickly, ready for the final painting in oil; this, in Pleissner's canvases, is applied as thinly as possible. He prefers a smooth-surfaced, slightly absorbent canvas. His painting medium—used sparingly —is stand oil.

The two close-ups of Pleissner's watercolor palette reveal an interesting organization of tools and materials. In the lower picture we see him lifting a small porcelain palette from a container which is used for storing all four of the small porcelain palettes, seen arranged for work in the other close-up. Stacked, one on top of the other, in the large pan, colors used one day are kept moist for several days by the two saturated cellulose sponges placed in the pan—with the cover on, of course.

The rubber ear-syringe is used to supply fresh water from the water jar for the mixing of large washes —a more efficient way than dipping up the water with brushes.

The upper picture shows the set-up of the palette ready for work. Pigments are arranged in the porcelain palettes and mixing is done on the large porcelain-top table. The three little bowls contain clean water. The two large pots are for cleaning brushes. Pleissner never dips his brush into clean color, or in clean water in the little bowls, until it is free from formerly used color. He is very meticulous in this, insisting upon clarity of color in his most delicate tints.

The few brushes lying on the palette show that he employs all types. The large one is a *Lyons* brush. Both flat and round sables are seen. He also uses bristle brushes. The instrument lying on a paint cloth will be recognized by feminine readers as an electric hair-dryer, a very useful tool for the watercolorist. Instead of waiting impatiently for a wash to dry, a blast of hot air from this instrument dries it in a trice.

Pleissner always stretches paper on a drawing board, at least for his large papers, whether the weight be 200, 300 or 400 lb.—he cannot abide even a slight buckling. He uses quite a rough-surfaced paper, but sometimes smooths, with a burnisher, a few small areas which are to receive delicate detail.

From what has been demonstrated relative to Pleissner's entire procedure it will be seen that he is orderly in his thinking and in his working. Perhaps that is equivalent to saying he is intelligent, for certainly it is the part of wisdom for any worker to organize his tools and methods in the most efficient manner possible. Yet that kind of efficiency is not as common as might be expected and so is worthy of mention here.

Pleissner's popularity is quite likely to be permanent because he is interested in the kind of subjects most people consider worth painting. He is no propagandist, out to reform society, unless it be through the contemplation of nature's delight. America will always have real need for the serene beauty of Ogden M. Pleissner's art.

PLEISSNER'S WATERCOLOR PALETTE

*Close-ups of Ogden M. Pleiss-
ner's watercolor palette show-
ing his orderly arrangement of
tools and materials and an in-
genious method of keeping pig-
ments wet over night, between
painting days*

Alfred A. Cohn photos

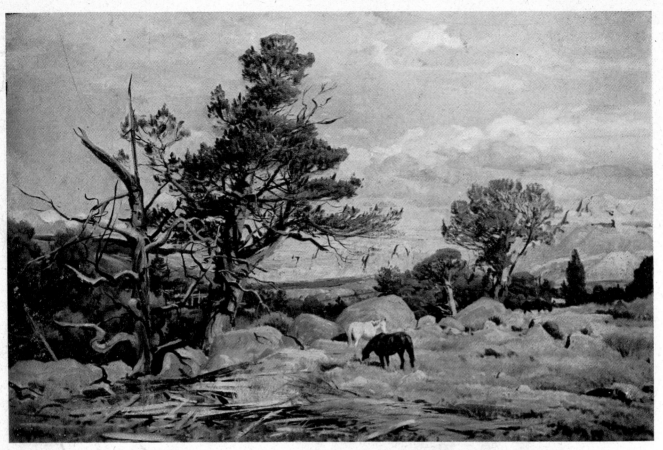

GRAZING (24 x 36) —— OIL PAINTING BY OGDEN M. PLEISSNER

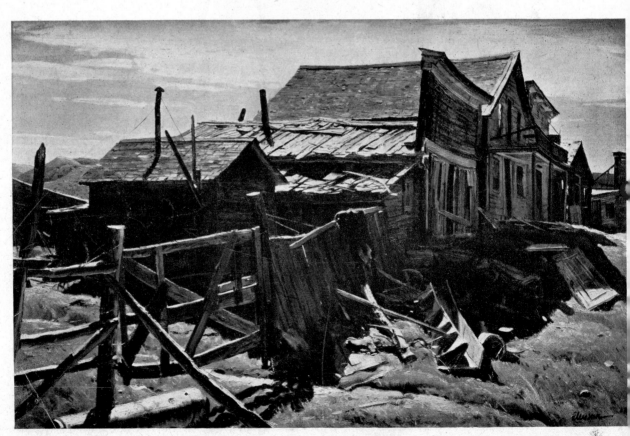

SOUTH PASS CITY (24 x 36) —— OIL PAINTING BY OGDEN M. PLEISSNER

82

PASSING SHOWERS (20 x 26) —— WATERCOLOR BY OGDEN W. PLEISSNER
Collection of Ernest M. Bull

Honorable Mention
International
Art Exhibition
Chicago Art Institute
1941

MONDAY MORNING (16 x 26) —— WATERCOLOR BY OGDEN M. PLEISSNER

LEON KROLL

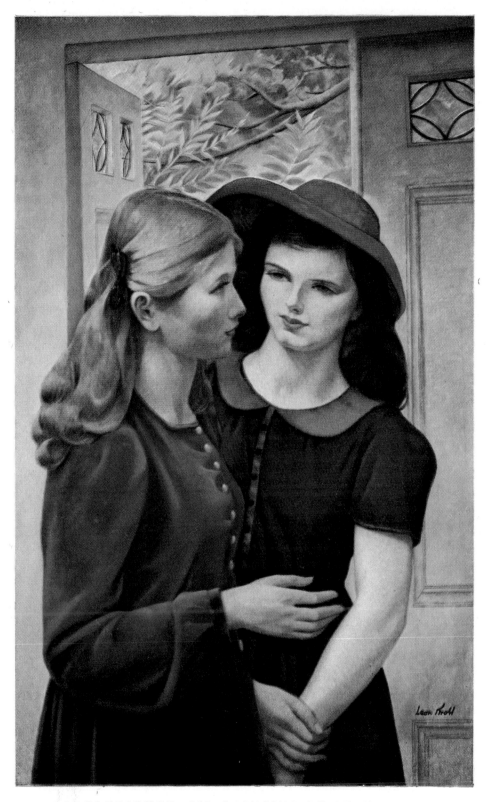

ADOLESCENCE—OIL PAINTING BY LEON KROLL

Courtesy Milch Gallery

Leon Kroll

LEON KROLL looks out on his world and finds that it is good. He translates his vision of it to canvases that have vitality and opulence. For him life is full, sensuous, and wholesome, and he is successful in imparting this to others."

Thus John J. O'Connor, Jr., wrote of Leon Kroll in 1937. Now, while civilization itself is shaking under the blows of global war, Kroll continues to paint the goodness and beauty of life and nature. Yet the war has come very close to him; family ties with loved ones now living in France have brought the experience of personal tragedy to the Kroll household. But Kroll knows that the seasons will continue to come and go, that the earth will yield its delights long after the fury of mad men has spent itself. In the meantime do we not need the consciousness of God's creative presence? Kroll gives us that assurance in his most recent pictures, in his exquisite *Adolescence* where the freshness and beauty of youth are seen to be as external as the seasons themselves. And in *The Hunter in the Hills,* with its age-old human story and the delights of the open country. Kroll, be it noted, peoples his landscapes, preferring "a landscape which has been loved and touched by the human hand and body." In the *Quarry on the Cape* the nude bathers supply that warmth of human association in a composition which is in Kroll's best manner.

Included among the good things of life, as Kroll senses it, and the inspiration of many of his canvases, is the beauty of women. His nudes are always painted with a dignity which expresses his adoration and his good taste. They have a grace that testifies to his competent craftsmanship—a welcome contrast to the treatment of the figure by so many contemporary artists.

Kroll's craftsmanship is in the great tradition. That tradition is founded upon thorough training in drawing, design and all the essentials of picture making. That has been Kroll's training. It began with study under John H. Twachtman, at the Art Student's League, and continued in the school of the National Academy of Design, the institution that has given sound professional equipment to many noted painters and sculptors. Kroll scoffs at the idea that a so-called academic training kills talent, declaring that "any talent that can be killed by training deserves to die, because it probably has no vitality anyway."

From the National Academy Kroll went to Paris where he studied under Jean Paul Laurens. Within four months he had won the grand prize for the nude. In 1910, when Kroll returned to America, he set to work eagerly painting the life and industry of New York. He had his first one-man show at the National Academy.

In 1913, invited by Arthur B. Davies to the famous Armory Show, he sold eighteen pictures in a week. He tells, with a chuckle, how he spent the ten thousand dollars with

happy abandon in a year—and didn't sell another painting for two.

But he began winning prizes in 1915. From that time on his career has been one of consistent progress, punctuated annually by the winning of the most coveted awards and honors that can come to an American artist. No contemporary painter is more widely represented in our museums and private collections. As a member of many art societies he frequently serves on juries for the big shows.

In 1936, the year he won first prize at the Carnegie International, he was one of eleven artists selected to decorate the then recently completed Department of Justice Building in Washington. That was his first mural commission. Two years later it was followed by his appointment to the task of painting one of the most ambitious murals ever executed in this country: the decoration of the Memorial Chamber of the Worcester (Mass.) War Memorial. The largest of these panels is 30x57 feet.

Mr. Kroll spent one entire year on composition and studies in a secluded studio in the country. Then he moved his household to Worcester and began work on the walls.

Believing that fresco was not suited to the particular conditions of the job, Kroll decided to paint the mural in oil on canvas. Here was a technical problem at the outset—you can't walk into a store and buy a canvas 30x57 feet. So a heavy linen canvas of the best obtainable flax, in a single piece, without seams or knots, was ordered from a London firm. Its manufacture required a special loom.

After the canvas had been secured to the wall, Kroll had it treated with three coats of gesso, spread just

Leon Kroll's palette is attached to an adjustable drawing table
Photo by Jane Rogers

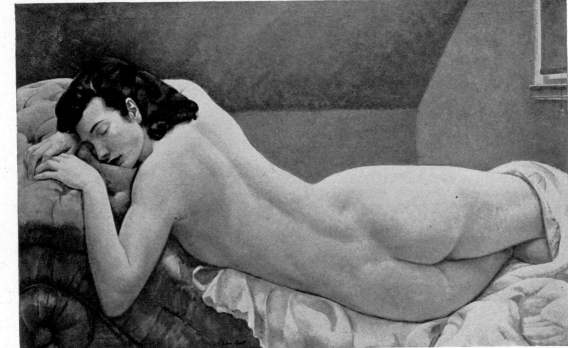

NUDE

ON

BLUE COUCH

PAINTING

BY

LEON KROLL

*The original is
26 x 42 inches*

thick enough to cover the top threads. Two talented young artists, who had been his students, assisted in the actual execution of the mural during a period of about a year. The entire work took three years of concentrated effort, and it was completed in 1941. It is a notable achievement.

The mural finished, the Krolls moved to Mt. Kisco, New York. Mr. Kroll now divides his time between this country residence and his studio in New York City. Although the rolling hills, furrowed fields and the broad spaces of nature are the main source of his inspiration, he is not a man for isolation. The call of the city with its motives, companionships and activities is one which cannot be denied for long.

Cape Ann on the Massachusetts shore has been a favorite painting ground for Kroll. Many of his landscapes come from the vicinity of Rockport, just north of Gloucester, as does the *Quarry on the Cape*.

Kroll's pictures of landscapes and figures are painted after considerable preparatory study. The landscape itself is usually a composite of various motives. The figures are carefully drawn from models, often starting with the nude, then with the same figure draped. These figure studies are done in charcoal on gesso-coated paper or board, and they are exquisite works of art. He prepares his gesso with equal parts of gypsum, zinc white and rabbit skin glue-water. This mixture is applied as smoothly as possible to the board with a broad varnish brush. The result is a highly sensitive surface which allows the greatest possible scope for the charcoal technic.

Mr. Kroll always prepares a special ground for his paintings. He gives his canvas two or three coats of lead white or gesso to cover up the threads and form a smooth surface. This ground is allowed to dry two

or three months. Often he mounts his canvas on board and prepares it with a gesso applied in several coats. This gives a brilliant white which is a factor in the preservation of the clarity of the pigments. When he wishes to re-paint an area he scrapes the offending passage down to the original ground. Every part of the completed canvas, in consequence, is fresh.

There are many qualities in Leon Kroll's work that explain its power. It is *design* that correlates them all. Design, in a Kroll picture, means the most sensitive play of lines, masses and colors in a pattern that is alive with movement. He says: "When I speak of

*Charcoal Drawing for a figure in Leon Kroll's
Worcester War Memorial Mural*

QUARRY ON THE CAPE — OIL PAINTING (27 x 36) BY LEON KROLL

THE HUNTER IN THE HILLS (30 x 48) — BY LEON KROLL

Figure study in oil for "Road from the Cove" which won First Prize in the Carnegie International. Another version in "Cape Ann" is now owned by the Metropolitan Museum of Art

One of about two hundred studies by Kroll for panels of his Worcester Mural

1 Ivory Black	5 Zinc White	10 Cad. Red Light
2 Ultramarine Blue	6 Cad. Yellow Pale	11 Cad. Red Deep
3 Cerulean Blue	7 Yellow Ochre	12 Mars Violet
4 Viridian or	8 Mars Yellow	13 Madder Deep
Vert Emeraude	9 Light Red	14 Burnt Sienna

design in a canvas I mean a fine organization of areas and shapes, a just balance of round and straight forms, intelligent use of horizontal, vertical and diagonal directions, a sense of the influence of three-dimensional form on two-dimensional pattern. All planned to include within allotted areas the forms of representation intended in the picture."

An interesting illustration of this "balance of round and straight forms" is seen in the *Nude on Blue Couch.* Note how the flowing curves of figure and couch are opposed by the straight lines and angles of the background; and the rounded forms of the figure compensated by the severe, flat wall planes. In the

figure itself planes of varying degrees of roundness and flatness combine to give the form vitality.

Subject any Kroll picture to the most critical analysis and you will discover that every square inch of the canvas is given just as much design attention as the total composition—in its proper subordination to the whole, of course. This is seen in the drapery of the *Nude* or in the hair of *Adolescence,* to isolate an example or two.

The composition of *Adolescence* is unusual; the disposition of the figures and background elements is artfully managed in that narrow vertical panel (26x42 inches); that size and proportion is a favorite with Kroll who reminds us that it is the proportion of the whirling square of dynamic symmetry.

Commenting on this picture the artist says: "The picture I call *Adolescence* is one of the first I painted after three years of concentrated work on the Worcester mural decorations. We had taken a place at Mt. Kisco where I frequently observed my daughter in conversation with a newly acquired friend who lives in the neighborhood. There was a charm and dignity in the relationship. The country studio, with its top light, windows and the open door, proved to be an interesting environment for the motif. I used the design of the leaves in the upper part of the picture to balance the patterned hands below. The rich color and the use of blue in the foreground with red back of it necessitated the accentuation of the black and white contrasts of the blue dress to keep the red in its place

On page opposite. Figure studies in charcoal on gesso ground. About 19 x 27 inches

LEON
KROLL'S
MURAL
IN THE
WORCESTER
WAR
MEMORIAL

This photograph by Homer St. Gaudens shows the elaborate scaffolding needed for this enormous mural

in the three-dimensional design. At the same time the weight of the two rich colors hold together as one mass for that area of the canvas. The absence of heavy shadows in the flesh parts make them function better in the design."

The *Nude on the Blue Couch* is also designed in a 26x42-inch panel. That subject presented problems quite different from those in *Adolescence*. "This picture," explains Kroll, "was primarily motivated by the discovery of an old couch in the garret at the house of a friend. I liked the shape and the tufts, but not the green color of the material. I borrowed the couch, organized my design in black and white. When I painted the figure, however, I spread a blue cloth over the green to get the right color relationship. I tried several ideas for the background, including a carefully designed flowered wall. While there was some rather pleasant painting in the flower pattern, the interest was too strong and pretty at the same time. So I invented the kind of garret which could be cut up into the shapes I needed to complement the figure.

"The pattern of the nude always fascinates me. It is never the same. After having studied thousands of nude figures, I am still enchanted by the wonder of it. The amazing variety of form and color seems inexhaustible. However, I find myself getting just as excited about a cow or a horse or a tree, a stretch of earth or any other form in nature which happens to be the right one needed in a painting."

The deserted quarrys at Rockport are the inspiration of many artists who spend their summers on Cape Ann. And no wonder, they are both dramatic and beautiful. The clear water of their depths reflects colorful rocks, green foliage, and the changing skies over this lovely spot on our coast.

"The Quarry on the Cape," says Kroll, "interested me as a motif because the forms and colors of the abandoned quarry with the water gave fascinating

material for the play of planes and shapes of all kinds. The figures repeat the warm sky, and the clothes in the right-hand corner accentuate the colors in other parts of the canvas. I painted (from nature) the relationships of the forms and colors as they moved back into space—without using much, if any, aerial perspective in the sense of the impressionist theory. Liberties taken with representation of two-dimensional contours helped the design, in my opinion."

We are impressed first, in *The Hunter in the Hills*, by the line pattern of the hills and fence in the foreground which bends back toward the distance, carrying the eye to meet the sweep of the background curves. "This picture," says Kroll, "was painted late last fall when the leaves blew away to give me a chance to see the handsome form of the rolling hills. The incidental figures in rich colors against the yellow ochrish hills are part of life in Westchester County. The dog seems rather doubtful about what the hunter is hunting, but I didn't think of that until after the picture was painted. Textures and spacing gave me many agreeable hours of study. The trees are selections from many scattered over the motif in nature. The picture was painted on an absorbent gesso ground."

As we pause to enjoy the paintings of Leon Kroll we find in them considerably more than an escape from troubled contemplation of a world in travail; they restore our serenity and give us strength when we return to the grim tasks that await us. We are glad that "Leon Kroll looks out on his world and finds it good."

DETAIL OF THE MURAL

Note the strong sense of figure structure beneath the garments. It is Kroll's practice to draw the figures first in the nude

ROBERT BRACKMAN

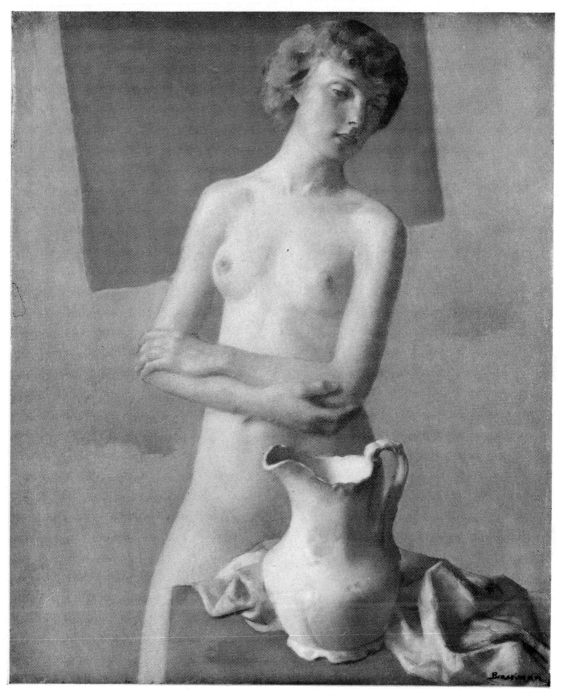

MORNING HOURS——OIL PAINTING BY ROBERT BRACKMAN

Courtesy Macbeth Galleries

Robert Brackman

THE man who hailed me as I stepped from the train at New London might have been, from his appearance, first mate just off a cargo ship. At least he looked like a sailor, in white dungarees, striped sweater and black-visored cap which, resting rakishly upon close-cropped black hair, shaded a set of weathered and rough-hewn features. Short and stocky—he is five feet, six inches, and weighs 150 pounds—Robert Brackman seems built for heavier work than wielding a paint brush, though of course that is far from the effortless task the layman imagines it to be.

From New London Brackman drove me over the seven miles of highway connecting that Connecticut seaport with the old fishing village of Noank, where the Brackmans have made their home. An abrupt turn from the main street brought us into Smith Court, a lane about three hundred feet long, leading down to the shore and into as snug an anchorage as any artist could desire. Brackman has made Noank his summer headquarters since 1926, but until 1938 he maintained a winter studio in New York. Then he bade farewell to 57th Street and the sidewalks of New York. First he built a large studio with an upstairs bedroom and a "Pullman" kitchen. Next came a house large enough to rear his family; there were Celia, one and one-half years old, Roberta, four and, of course, Mrs. Brackman, who formerly was Frances Davis of Toledo. Next came the "school," a fine large studio which will accommodate fifty students at a time—and none too large at that, for Brackman is one of America's most sought after teachers of painting.

These three buildings, gleaming white against the blue of the bay, comprise a veritable artists' haven. No wonder Brackman has chosen to become a permanent citizen of Noank.

On Brackman's easel, that July day when I visited him, was the figure painting which is reproduced here in color. It represents a noticeable step in the artist's trend toward greater simplification in composition and, in color, toward the painting of "light and the haze of light" which Brackman repeatedly talks about when discussing his painting. It is painted in a somewhat higher key than former canvases and the beautiful flesh tones, though subtly restrained, have a pervading fullness of rich color.

In this canvas, it will be noted, one of Brackman's pet jugs plays its part in the symphony of form and color. Brackman rarely paints a figure without still life.

Indeed the museum or private collector is almost certain to insist upon a semi-nude *with still life;* thereby getting a double value, as it were. For Brackman's reputation would be secure were he to confine himself to either type of subject matter. However, he loves his jugs and apples so ardently that he scarcely considers a canvas a picture unless his classic figure compositions are accented by a pitcher or a basket of fruit, with perhaps fish or fowl thrown in. These accessories are so masterfully painted that Brackman fans scarcely know which to admire more, the semi-nudes or the *nature morte.*

Much as I relish the former, it was an exquisite little still life that first impelled me to write a Brackman article and it is my sustained intention to put the emphasis, in this discussion, upon that phase of the artist's work although, as has been implied, that phase cannot be considered wholly apart from the other.

It was in Grand Central Art Galleries that I saw the Brackman painting, reproduced in halftone at the top of this column. I am going to quote what I wrote in my notebook as I sat before that little still life.

"One of the rarest experiences of the gallery visitor is to discover a really thrilling still life. For in a still life the painter reveals his true measure as an artist and craftsman. I wish you might see the original of Brackman's oil painting, but I am hoping that even with color subtracted (in the black and white reproduction) and the great reduction of this small cut (the painting is 16x20 inches) the reader can share something of my enthusiasm for this remarkable picture.

"Remarkable? What can be remarkable about the painting of a few pieces of fruit lying upon a table with a crumpled napkin? The wonder of it lies in a painter's ability to embody so much of his genius in such simple subject matter, to be able with only these common objects to make something inside us cry out with joy.

"Of special interest is the very narrow range of values in this study. The lightest part of the white napkin is far from being white and the darkest notes—the shadow sides of the dark blue plums—do not touch the bottom of the value scale; a very restrained tonal scheme.

"The picture is full of the most delicious subtleties. The background—a reddish gray—is deepened in value just behind that white spot needed for accent; the table top is alive with changing reds of slightly differing values; the fruit, which has a fine tactile quality, is

Two early Brackman canvases, painted in 1932 and 1933

painted with the most artful expressions of form. The pears, peaches and apples *feel* so good, not as real fruit—it is not very realistically painted—but as painting quality, appealing to the esthetic rather than the physical taste. The esthetic appetite is likely to pall when offered pictorial fare that too obviously appeals to the physical appetite, when realism is more important to the painter than art qualities which have nothing to do with representation.

"Because Brackman has given this painting enduring qualities of masterly craftsmanship this fruit will never lose its flavor, no matter how long it hangs upon the wall of its lucky owner.

"I have spoken of the narrow value range of this picture—that can be seen even in the reproduction. The color range is fully as restrained; there is no bright color in the painting, and yet—darn it—how the thing sparkles and sets our appetite tingling! It must be a bit maddening to another painter who has struggled almost hopelessly with a similar problem."

When I entered Brackman's studio in Noank I looked about for three objects, one of which is almost certain to be seen in a Brackman still life: the two pitchers—one chaste and severe in form, the other flowered and frilled—and that glorious old table which, in its patined finish and rich coloring, adds so much to his canvases. The table turned out to be not glorious at all; it is a very ordinary kitchen table. All that color, texture and time-worn beauty of the table in the pictures is really from the artist's imagination.

The ornate pitcher might have come from the commode in any Victorian home. The other jug is really a beautiful piece though it cost no more than a dime at a Salvation Army store. It has a fine form, as can be seen; its crackled glaze is an exquisite neutral gray which makes it a good reflecting surface for purple grapes or green apples.

These objects, it will be noted, are not to be seen in the early still lifes painted ten or more years ago. Their appearance in later compositions identifies them with simplicity and power which today make Brackman one of a few good painters of still life; a coincidence, of course, unless it be that his realization of the need for simplicity brought these two pieces into his studio to serve time and again as models.

There is no better way to appreciate Brackman's development as a painter and to study the trend of his expanding genius than to put one of those early still lifes alongside any of his recent studies. Note in the former how relatively busy is the canvas throughout, how scattered the interest. What a contrast to his recent pictures! Here we see the artist composing like a master with largeness of conception and power of statement. There is always a dominant interest—usually one of these two jugs—with all other elements complementing and supporting it. The whole colorful group is dignified by space, subtle gray backgrounds against which the solid forms of the objects make an impressive display. These contrasts in early and later work apply equally to Brackman's figure compositions. There is the same seeking for the essence of the motive, the same elimination of all that does not add to its power. "When a composition looks wrong," says Brackman, "I subtract something from it. Elimination will nearly always improve it."

On this page are four of Brackman's recent still lifes

What shall we say of the repeated use of these few objects in Brackman's still lifes? Is such a practice of repetition strength or weakness? I like to think of this later series of still lifes as parts of a great symphony in paint—call it the "Symphony of the Jugs"—extending over the years. In each picture, as in various movements of the symphony, we have the recurrent theme, a repetition which we enjoy through the recognition of familiar notes appearing and reappearing, but in varying moods and tempos, each one a distinct message of beauty though part of a single song.

In great racks in a corner of Brackman's studio are many canvases in sizes varying from 12″x16″ to 7′x9′. They are all stretched and waiting. "I don't know when I'm likely to 'bust' out with a picture," he says, "but when I do I want just the right canvas ready to hand."

He always has several pictures going at once. He will start one, carrying it through the first phase of painting, laying-in the vital colors, then put it aside while others are begun. When he takes one up for final painting he sticks to that canvas until it is finished, allowing himself to be diverted by nothing except perhaps for drawings or pastels which he may make for relaxation between painting periods. He usually takes a month for a still life painting. A large figure composition may keep him busy three months.

Brackman never paints without a model. Even when he is occupied with a background—he says those gray backgrounds are the most difficult part of his pictures—his model must be posing. He recalls that he even had John D. Rockefeller, Jr., whose portrait he painted recently, sit several times while he worked only on background.

He finds his models among the local residents of Noank. Mrs. Brackman has posed for many of his pictures. Soon, no doubt, Roberta will be old enough to sit for him.

Perhaps there is no better way to explain Brackman's approach to his own painting problems than to quote what he said to me about his teaching methods, as we stood in his school studio at Noank, where his students were painting from the nude model.

"The student's first problem," he said, "is the design of his picture. He must be conscious of the dimension of his canvas; be concerned with the placing of his subject so that it will break up the canvas area into the most interesting pattern.

"He should at once study the matter of scale, the proportion of the subject to the dimension of the canvas.

ROBERT BRACKMAN'S PALETTE

Brackman mixes his pigments in only a relatively small area which is cleaned after the day's painting. Pigments are allowed to pile up elsewhere

Then he begins to study action, sketching freely with a large brush in very light colors until he has registered the characteristic movement of the figure. Next he begins to construct the figure with his brush without being in haste to paint or even thinking about painting.

"The most difficult thing to teach, really, is the distinction between *construction* and *drawing*. It's natural for the student to be more concerned with drawing when the model is before him. He has to be taught that construction rather than drawing is the foundation of the painting. By construction I mean the big structural elements of the painting conforming, to be sure, to the facts observed in the model, but with emphasis upon design and the relation of all the elements to each other and to the canvas as a whole. This is the creative approach to painting in contradistinction to the copying attitude of the student who focuses upon literal drawing of the figure while the canvas is in its formative stages.

"After the construction has been studied with brush-drawn lines the shadows are laid-in with the actual tones of color, comparing the darks to the whites of the canvas. Then the background is covered with tone. The construction lines have now disappeared.

"In subsequent painting one must approach the problem purely from the color point of view, establishing first the darks, then the middle tones to white canvas, thinking of the abstract qualities of color and tone rather than the pictorial interest of the subject. One should place color for color as one sees it without shaping the objects with the brush or correcting the drawing. When the darks of the subject are correctly established in relation to the background, color and values in the lights can be more easily visualized.

"When the entire canvas has been laid-in in proper color one is ready for shaping it into correct drawing and texture. Thus drawing comes last rather than first.

"The Impressionists taught us the proper approach to painting. And that, as I have said, is the most difficult lesson for the student who thinks of *drawing* as the natural approach. But that is not the painter's approach. A painter's drawing is only completed when his canvas is finished. For him there is no separation of drawing and painting; he draws as he paints and paints as he draws. The conception of drawing as separate from painting results in colored drawings."

Among the old masters to whom Brackman is chiefly indebted are Ribera, Titian, Manet, Frans Hals, Degas, Cézanne and Picasso. From Ribera came conceptions of form, realism and composition; Hals and Manet have inspired his color as has Cézanne who also taught him the unimportance of subject matter. And to Cézanne belongs the credit for Brackman's enthusiasm for still life. "Picasso," he says, "brought me back to classicism."

"I admire Titian," declares Brackman, "because he could take an ordinary man and make a heroic figure of him, giving him a universal quality that awakens a response in every man who looks upon the canvas. That really expresses my own philosophy of painting. My

A RECENT STILL LIFE PAINTING BY ROBERT BRACKMAN

Courtesy Macbeth Galleries

greatest aim is to bring my art to such a simple and understandable form that the common man can enjoy it regardless of subject matter and without the need for interpretation. Even ignorant people worshipped the old masters. That is as it should be today."

Brackman makes no preparatory studies for his pictures either on paper or on his canvas. There is no preliminary drawing or painting of any kind. He conceives the composition mentally and attacks the canvas directly, laying-in the broad masses, breaking the spread of canvas into primary pattern areas and constructing his forms as he develops his color motive. He leaves as much of the raw canvas showing (in the light areas) as possible.

In the first phase of his painting he works with great fullness of color, "to establish the vital color" as he says. His canvas is then laid aside for a time, the while he starts other pictures.

In the final painting he tries to paint what he calls "the drama of light." Over these "vital" colors he superimposes a tonality which has underlying richness of color but is overlaid with a "haze of light." He does this not by glazing but by painting always with dry pigment. He uses no medium at any stage of the painting. If the pigment piles up too much he scrapes it off with his palette knife. If a change is to be made in color at any point, the canvas is there scraped clean of pigment. Now and then he uses a little retouching varnish to freshen the color.

One is conscious, in a Brackman canvas, of great restraint. Colors, though rich and varied, are seldom brilliant. Brilliance, the painter reserves for a few accents at focal points and never can you find a color which might have come fresh from the tube. To achieve this tonality much of the canvas area is built up in grays which by contrast give great vitality to the subdued colors of the brighter areas.

This restraint is seen in the values as well as in the handling of color. Note how cautiously he paints his highlights. Hold a piece of white paper against his lightest pigment and see how sparingly Brackman has used his white. He never hits the lightest possible light.

Although Brackman is not consciously analytical—in a mechanical sense—he has an intuitive feeling for design which reveals itself in his meticulous consideration of every detail of the picture. This expresses itself in as incidental a matter as the placing of his signature upon the completed canvas. The signature sometimes goes on the *back* of the canvas because there is no place for it on the picture itself. Sometimes he brushes it in at one point, then, not satisfied with its position in the design, paints it out and tries it in another place.

Although Brackman doesn't make preliminary drawings for his pictures he is always drawing. When tired of painting he draws from the model, often in pastel. Indeed his pastels are admired quite as much as his paintings and they have found their way into many museum collections. Occasionally he will do pastel studies of the head preparatory to a portrait painting as he did when he painted Charles and Anne Lindbergh.

Among the other personages Brackman has painted are John D. Rockefeller, Jr., Francis Weld, president of

the Harvard Club of New York; Bartlett Arkell, benefactor of the Canojoharie Museum, and Alvin T. Fuller, former Governor of Massachusetts.

Robert Brackman was born in Odessa, Russia, September 25, 1898. His parents brought him to America when he was twelve years old. He studied art first in the Francisco Ferrer School, then at the National Academy of Design. Later he was a pupil of Robert Henri and of George Bellows, two of America's greatest painters and teachers.

The art world soon took notice of Brackman and he began winning painting prizes. Museums started collecting his work and they continue to buy his canvases. The National Academy of Design elected him to its membership. Brackman has for several years given some of his time to teaching, principally at the Art Students League of New York. He has conducted his own private school at Noank, Connecticut, for many seasons.

Robert Brackman at 44 and in the prime of life has traveled far upon a path that promises to lead to great accomplishment.

THE MARKET WOMAN

Painted by Brackman in 1938

Collection of New Britain Museum

ON THE SHORE OF CONNECTICUT —— OIL PAINTING BY ROBERT BRACKMAN

This, the latest Brackman canvas at the time of writing, is 7 x 9 feet

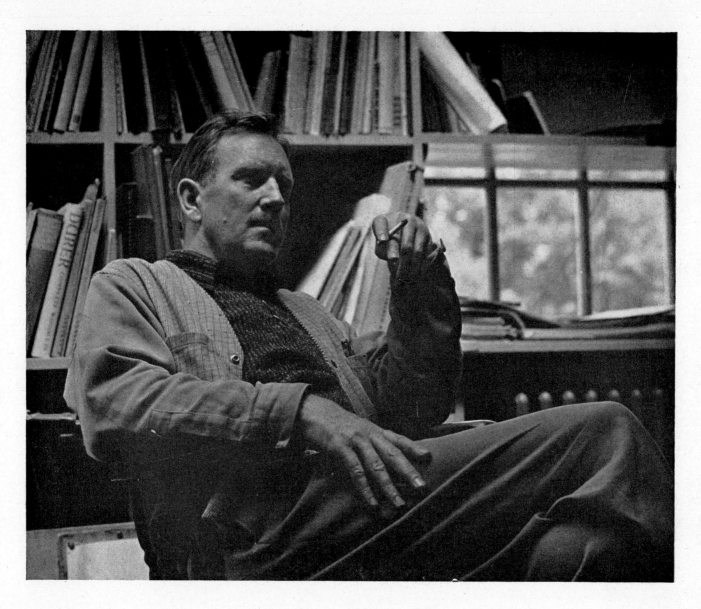

PAUL SAMPLE

SWEET HOUR OF PRAYER——WATERCOLOR BY PAUL SAMPLE

Courtesy Associated American Artists Galleries

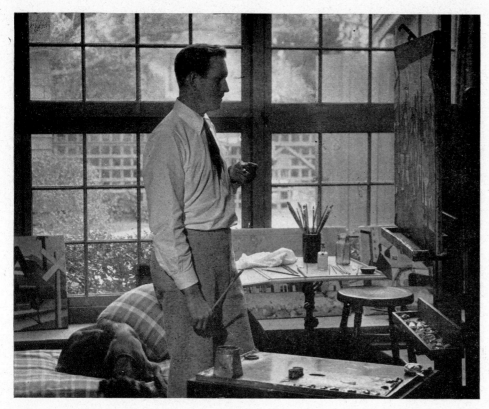

Paul Sample

THE picture reproduced in color was selected because it is undoubtedly one of Paul Sample's best performances in watercolor. Painted in a satirical vein it is, in subject, not at all characteristic of this New England artist who does not often focus upon individuals – almost never paints them emotionally. People in his pictures more often are incidents in a general scene with emphasis upon the landscape and its buildings. His usual point of view is impersonal, is that of a Gulliver who surveys the broad landscape from a considerable distance, observes the inhabitants going about their business, disposes them in his pictures where they will do the most good in the composition. He seldom descends upon these human actors to peer into their souls to see what part fate has assigned them in the drama of life. This is true even in such a picture as *Matthew 6:19*, a midwinter auction on a farm which the deceased farmer is watching from the clouds of a wintry sky. Even here the interest is objective; we feel that the artist is more concerned with picture making than with dramatizing the text, "Lay not up for yourselves treasures upon earth."

All of which is equivalent to classifying Sample as a genre painter. His special idol among the old masters is Peter Brueghel the Elder, one of the greatest genre painters of all time; and the influence of this Flemish master in Paul Sample's work is conspicuous.

Sample is not an introspective painter. He is more interested in externals, in things seen rather than deeply felt. He responds to almost any kind of subject matter although his love for the Vermont countryside and its people is seen in enough of his canvases and watercolors to invite the critics' label of "regional." But you could settle Sample anywhere on the map without making him homesick. He has a remarkable adaptability. This is illustrated by the superb set of paintings he did for *Fortune* in 1937.

He was assigned the task of painting eight of our country's principal seaports, in connection with an article on their competitive commerce. His renderings of these harbors are what used to be called bird's-eye views. They are meticulously drawn in great detail, suggesting that the artist must have had some architectural training, which is not the case. They do testify to an all-round technical facility and to a youthful alertness to the wonders of nature and the works of man alike.

So it is that, emotionally, Sample lives off the country, as one critic very aptly has put it. His western subjects, done during the period when he divided his time between California and the East, reflect exactly the same enthusiasm as the later Vermont scenes for which he has become better known.

One of the first impressions of Paul Sample's work is his love of clear cut, sharply defined rendering of form, whether it be landscape, buildings or human figures. Very few of his pictures, whether of West or East, are what can be called atmospheric. The eye, roaming over his panoramic landscapes sees that no detail has been neglected, even in the distance where a tiny plowman drives his team over the spring fields. Yet with all this literalness there is simplicity and largeness of design. The net result is a picture which has its appeal for layman and critic.

Born in Louisville, Kentucky in 1896, the son of a construction engineer, Paul Sample spent his childhood here and there – wherever his father's work took him. That was pretty much all over the U.S.A. Paul wound up in Dartmouth College where he appears to have majored in football, basket ball and boxing. At any rate he became collegiate heavyweight champion and acquired a love for the prize ring which has furnished him with subject matter for quite a few of his pictures. A year's service in the

PAUL SAMPLE
PAINTS A WATERCOLOR

At Grupp's Gymnasium in New York's Harlem, Paul Sample painted the watercolor shown at the top of the opposite page. After spending a half hour making preliminary pencil sketches of the boys in action, Sample induced one of them to pose with his trainer for a short time as the basis for his painting. The development of his painting is shown herewith in the photographs of progressive stages. For further description turn to page 117.

Alfred A. Cohn photos

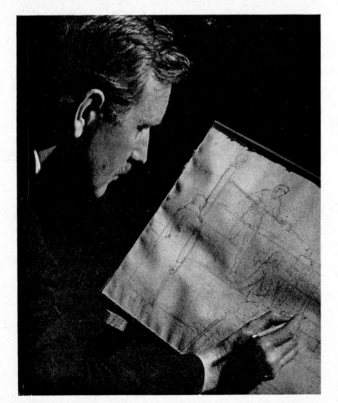

TWO WATERCOLORS BY PAUL SAMPLE

Both watercolors were made at Grupp's Gymnasium in Harlem, New York. Paul Sample, once heavyweight champion at Dartmouth College, is a boxing enthusiast

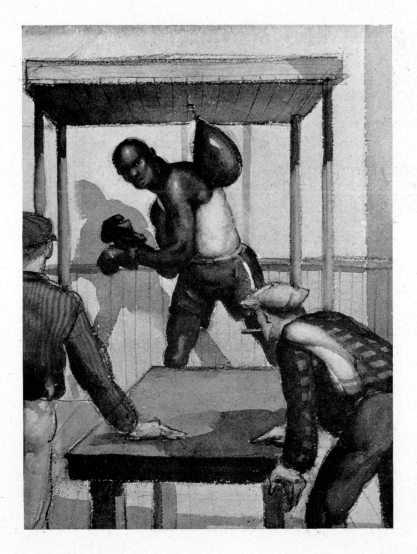

BEAVER MEADOW (40 x 48) — OIL PAINTING BY PAUL SAMPLE

MOUNTAIN VILLAGE — OIL (18 x 30)

Navy during the first World War interrupted his work at Dartmouth but he was graduated in 1921.

Sample spent the next four years fighting tuberculosis at the Veteran's Bureau Hospital at Lake Saranac. To counteract the boredom of these tedious years he began experimenting with pencil and brush; but he had no formal instruction in painting until after his discharge from the hospital when he studied with Jonas Lie and at the Otis Art Institute in Los Angeles. In due time he was invited to join the art faculty of the University of Southern California and finally became head of the painting department. Following his marriage in 1929 to a Vermont girl, Sylvia Ann Howland, the Samples spent their winters in California and summers in Vermont. This accounts for the mixture of East and West Coast subjects. However, in 1937 the Samples moved away from California for good; after a few months spent in Europe they settled in the East. It was then that Sample accepted the invitation to become Artist in Residence at Dartmouth College, Hanover, N. H.

In 1934 Paul Sample held his first one-man show at the Ferargil Galleries in New York. It brought him to a position of prominence among American painters. When his *Barber Shop* won a prize at the Carnegie International, and the Metropolitan bought *Janitor's Holiday* his position was definitely established. His pictures continue to win prizes and are constantly seen in reproduction. He has been the subject of numerous magazine articles.

Paul Sample divides his interest between work in oil and in watercolor. While some of his most noted pictures have been canvases, many of his admirers are particularly enthusiastic about his watercolors. This medium seems especially adapted to his clear, sharply defined vision. At any rate he uses it with

BARBER SHOP (35 x 40) ——— OIL PAINTING BY PAUL SAMPLE

great effectiveness, particularly in his snow scenes where it permits the utmost economy of means.

Frequently when Sample comes to New York he spends a half-day at Grupp's Gymnasium in Harlem. There, many years ago, Grupp — formerly a professional fighter—set up a boxing ring which has been used in training several famous champions. Today it is patronized by ambitious boys from the colored population now resident in that section. The pictures shown on page 114 reproduce steps in Sample's watercolor painted on one of these occasions.

Before getting out his colors Sample spent an hour with his pencil, making a number of rapid sketches of the boys training in the ring. When finally his conception crystallized, he got one of the boys and his trainer to pose for fifteen or twenty minutes while he made sketches of the action desired for the watercolor. He then began with pencil on his watercolor pad and spent a good half hour on a careful drawing before taking up a brush. He likes to have his subject carefully delineated so that he can concentrate chiefly upon the color when he begins to paint.

Sample usually stretches his paper but for convenience in working in the present situation he provided himself with a 16x20 pad of medium heavy paper. As soon as wet washes were applied to large areas the paper wrinkled considerably, though not as much as appears in our cut, where the photographer's light enphasizes this unwelcome condition.

The ring was illuminated by an overhead unit but the gymnasium was otherwise dimly lighted and far from colorful, so the color of the picture had to be quite arbitrary. The only bit of bright color is the red robe on the standing figure.

Paul Sample is definitely an *American* painter. His pictures have native flavor not only in their faithfulness to the countryside they portray but in a kind of homespun sincerity which appeals to the average citizen of Main Street, U. S. A.

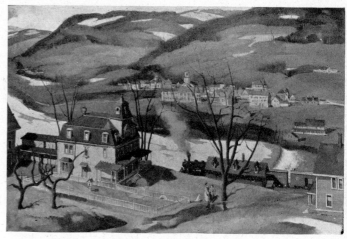

THE PASSING OF WINTER (26 x 40)

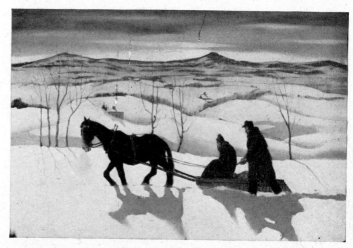

GOING TO TOWN (26 x 40)

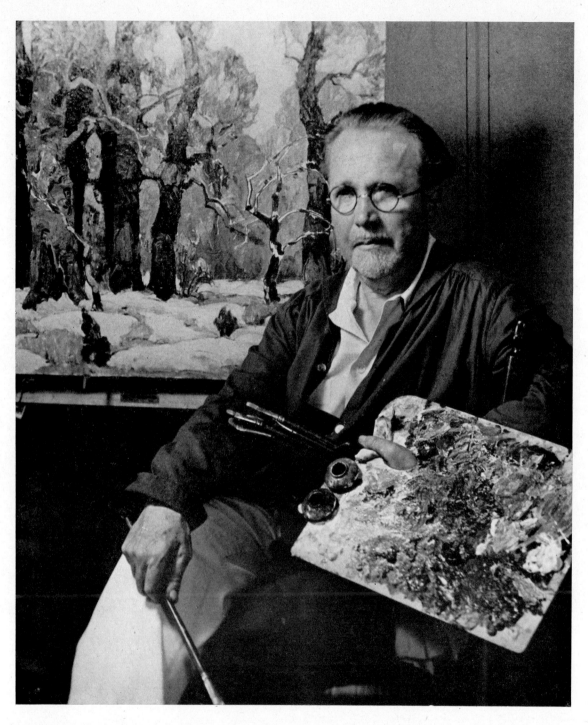

JOHN F. CARLSON

QUIET GROVES——OIL PAINTING BY JOHN F. CARLSON

Courtesy Grand Central Art Galleries

John F. Carlson

"I would rather be in the woods than any other place on earth," says John F. Carlson, "and I've spent a good part of my life painting trees. Naturally I've gotten pretty well acquainted with them. Excellent friends they are and, for me, the most fascinating 'sitters'. Trees are a lot like human beings; rooted men, possessing character, ambitions and idiosyncrasies. Those who know trees see all their whims; see their struggles too; struggles with wind and weather; struggles to adjust themselves to their society. For nature will not allow them to run amuck, heedless of their neighbors; their individual propensities must conform to the cosmic laws within their own democracy. Thus there is a certain rhythm in a wood; a flow between parts, a give and take that is rigidly observed.

"No one, it seems to me, can really paint trees without being extremely sensitive to their rhythm and all that is going on in the woods, without indeed having considerably more than a casual acquaintance with sylvan society."

It ought, of course, to surprise no one that John F. Carlson, famed painter of the forests, is an adopted member of that society. Former students who may chance to read this will recall how their master sought to introduce them into the fraternity of his beloved trees, taught them the etiquette of their companionship. Characteristic of his introduction are the following lines copied from a student's notebook:

"When starting out for a day of painting in the open, first get rid of that mild frenzy that is apt to take possession of the inexperienced. Pretend you are a disinterested party. Relax, gradually slither yourself into the environment you feel to be harmonious with your in'ards. Don't begin by boring into facts like a scientist. Loaf around, smoke your pipe, ruminate all by yourself. Give nature a chance to begin singing to you. Gradually a plan or idea will emerge. Analyze the *idea*, not nature.

"Then paint the idea. After this you are ready to check up on such constructive facts as you may need. But don't let facts disturb your idea; make them conform to it.

"Take a long time composing your canvas because the composition will either make or break the picture. As you work along, don't be afraid to make drastic changes as they suggest themselves. They will be suggested; compositional needs spring up *because* of the things you have already set down on your canvas. When you feel a composition needs to be changed, change it at once before the composition changes you.

"When a picture is 'coming along', many factors enter into its progress

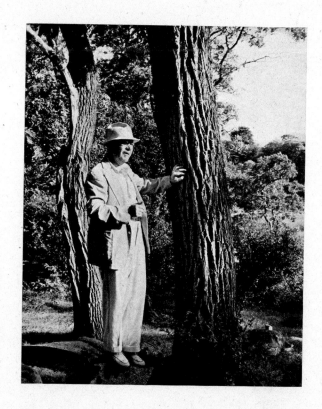

which cause you continually to modify your original conception. While the motivating idea ought to be preserved, accidents develop which should be made use of. (Blessed is the man who knows how to take advantage of a *good* accident!) You will be forced to change your mind about many things. That is all right so long as you retain your dominant motive. A musician may rewrite many bars of a *largo* but he will never let his composition become a *scherzo*."

Again, "After you have decided upon the motive you wish to paint and have become thoroughly acquainted with it, turn your back to it and compose your picture in its entirety before permitting yourself another look. In that way you will be likely to conceive the picture as you feel it. The accidents of the scene will not interfere with that conception. Afterwards consult nature as much as you choose for facts of structure, color, textures, etc. This check-up will encourage you to fill every part of your canvas with interesting material."

All of this gives pause to the thoughtless beginner who is inclined to rush about looking for a "picturesque subject," then confidently to sit down to paint without even feeling the need of an introduction to the bit of nature that he hopes will, when transferred to his canvas, convey something of nature's charms he himself has not taken the pains to experience.

"There is nothing very unusual in my method of procedure," says Carlson. "I never push myself into a decision as to what to paint. During the year, and especially in winter, I make numerous sketches outdoors— in Vermont, New Hampshire, and upper New York State. I do not make these trips to 'find pictures' but to freshen myself physically and mentally. I sketch both in oil and in pencil but never paint a large canvas outdoors.

"In these studies I strive mostly for the color relations of the large masses. Of course I try to compose as well as I can in the limited time but the real composition study for my pictures comes later. I draw as well as I am able but do not worry a great deal about that, for I can always go back with pad and pencil if more facts are needed. What I do worry about are the big forms or shapes, but even these can best be mulled over in the studio—and they require plenty of mulling!

"Back in the studio the real creative work begins. The impressions gleaned from my study in the woods begin to crystalize. A picture finally springs into being, takes shape in my mind quite completely. I don't start to paint until I can see that picture with my mind's eye as clearly as though it were before me on the canvas. Thus it will be under-

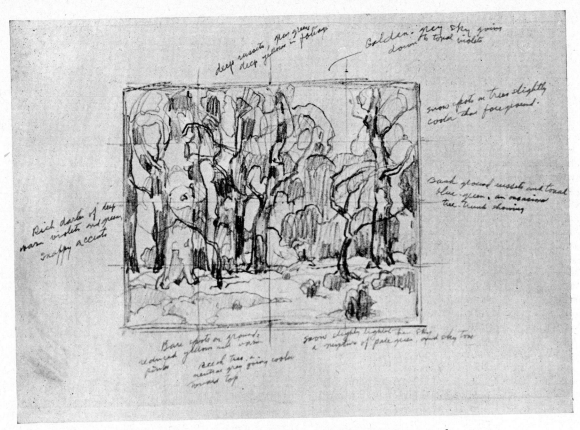

Before starting to paint, Carlson customarily makes a penciled composition, a transitional step between his mentally conceived picture and its consummation on the canvas

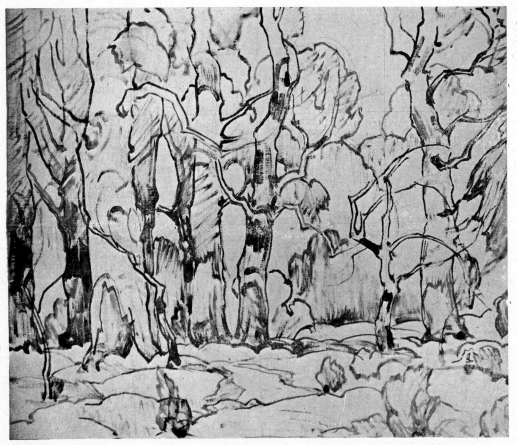

Following the pencil layout he begins to draw with his brush on canvas, using a mixture of neutral, warm violet-gray oil paint

Photography by
Cushing-Gellatly, Boston

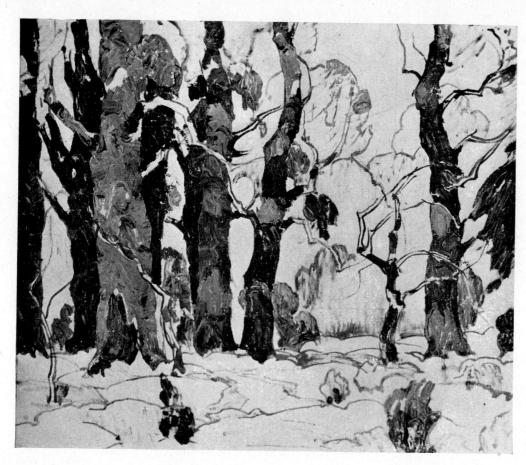

The dark masses are first laid-in with pure, rich color applied with the palette knife and stiff bristle brushes

Intermediate and light tones follow, working up in value scale from the darks. The completed picture, "Winter Idyl" is on a following page

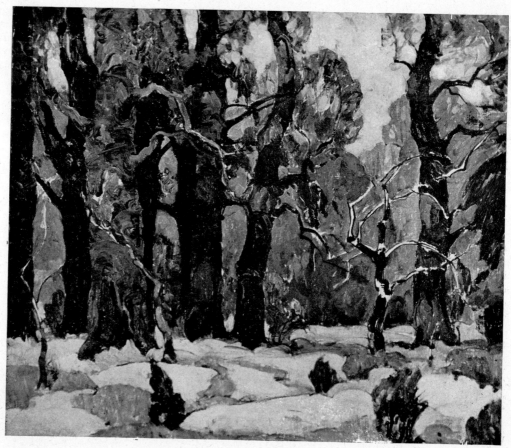

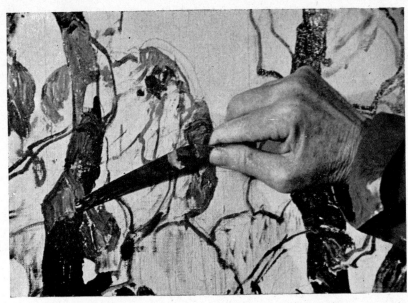

Carlson likes to apply his pigment with the palette knife

stood that the studio-painted canvas is in no sense an enlargement of an oil sketch painted outdoors. Sometimes, to be sure, such a sketch becomes the basis for a picture but only when a picture concept has built itself up around that sketch, developing into something quite beyond the content of the small study. The mere enlargement of a sketch results in areas of emptiness and a dull canvas. The larger the extent of the canvas the greater the art required to make the picture vital.

"Having thus created the picture mentally I begin work on the large canvas. I work deliberately, very slowly in these later years, especially over the organization of my composition. First there is the consideration of the shape of the canvas. Will the particular theme be best exploited in a longish, squarish or upright canvas?

"Usually I make a pencil layout on paper before beginning any work on the canvas. This is a useful transitional step between the mental conception and its realization on the canvas. It makes for more directness in attack when one picks up the brush to paint. I never draw on canvas with pencil, charcoal or crayon as I dislike any foreign substance on my painting surface.

"After this pencil layout I begin to draw on the canvas, brushing-in outlines of the big forms with a half-dark mixture of rather neutral, warm violet-gray.

"The next step is to smear in the masses, darks first. In this lay-in I paint the colors a trifle darker than they will finally be and make them more vibratory. The canvas, at this point, is set aside for a few days. I do not expect anything of this first painting except that the main compositional masses be correctly established.

"Bear in mind that I have previously determined upon the general color key or tone for the whole; I have decided whether it shall be dark or light, mellow, cool or cold; whether the forms shall lean toward the severe or the playful or a quiet, meandering mood.

"When I take up the canvas again I re-paint the masses but do not obliterate the underlying color. I modify the intensities as needed. I like to start a canvas with the palette knife and vigorous bristle brushes. These apply the paint in a 'fatter' way. For the final paintings I use Bright's sable brushes; invaluable for 'dragging' one color over another.

"I'm careful not to grind the colors together, as that would destroy the vibratory luminosity which results from juxtaposition of pure hues. On the other hand I never leave hunks of paint to stick out in order to make my technic appear 'bold.' I create texture where I need it; not all over.

"Once the big color relations have been established I try to bind these together in the 'unity of light' which pervades them. This requires a good deal of going back and forth, slightly changing the tones that are out of harmony. I do not re-paint such tones but I jab other colors into them until I have swayed them into harmony. This procedure insures color vibration within the masses and engenders luminosity.

"I paint my darks with pure colors, never with black or brown pigment. After deciding what the dominant color of the 'black' is to be—cool, warm, or hot—I mix that exact shade with my deep blue, deep red and deep yellow or veridian green. Browns and blacks are especially unfortunate in landscapes. So are manufactured violets and oranges; they produce a tailor-made set of colors that lack vitality.

"In oil painting one almost invariably lays-in the darks first; just the opposite approach from watercolor in which it seems natural to begin with the lighter tones.

"While I paint my darks with pure colors I am careful not to load them with too much paint. I put the paint on thick then give it a swipe with the palette knife, reducing the gobs of pigment to a nice 'fat' enamel-like texture. I frankly enjoy paint *as* such. I believe an oil painting should look like an 'oil' painting *a la Rubens* and not present a poor, stained-in, watercolor-in-oil effect full of accidents.

"As I paint in the masses I add drawing and accents. Details need no attention until the canvas is almost completed. Thus, if a tree is adequately treated as mass, volume, color and value, very little detail of branches and leaves is needed—the less of this the better. In this lies the difference between drawing and painting. The draftsman deals with the outline form; the painter with mass meeting mass, without any real outline. A painting should not be a colored drawing."

Carlson always has four or five canvases in process. He never works more than a half day at a time on any one. When he tires of one he takes up another. He says he keeps his enthusiasm at white heat in that way. He may take a whole year on a given picture, painting other canvases the while. Canvases occasionally lie around

WINTER IDYL — OIL PAINTING BY JOHN F. CARLSON

Carlson's canvases have a fat, enamel-like texture. He says, "I believe an oil paint-
ing should look like an 'oil' painting a la Rubens. I frankly enjoy paint as such"

TREE RHYTHMS ——— BY JOHN F. CARLSON

his studio for three or four years, gradually developing as from time to time they are brought out to the easel for painting. He has never painted a picture in one "go." He is sure his best pictures are evolutions rather than sight paintings.

As to technic Carlson is devoted to pure, unadulterated oil painting. He sees no virtue in tempera underpainting. "Never underlay an oil painting with substances foreign to good old oil paint," he says. "Linseed oil and pure turpentine are known quantities. Oil of copal varnish added to this medium is a safe body-giver for the pigment. I use this trio as painting medium and as a final varnish. I've never had a painting crack, fade or bloom."

On Carlson's palette the following pigments are set in graded sequence from white to dark as listed below.

1. Lead White (Cremnitz, Flake)
2. Lemon Yellow
3. Cadmium, light
4. Cadmium, medium
5. Transparent Gold Ochre (not Yellow Ochre)
6. Cadmium Red
7. Rose Madder
8. Veridian (Emeraude)
9. Permanent Green, light (for summer painting)
10. Burnt Sienna
11. Prussian Blue
12. Cobalt } for still life
13. Ultramarine } and flowers

"Prussian blue I have used for thirty years, to the despair of paint manufacturers," says Carlson. "It is the only blue with which a 'sappy' dark green can be made. All other blues have a purple cast and turn gray when yellow is added. Prussian is the only blue which keeps its identity under artificial light—other blues go pinkish: for blue skies and shadows on snow it gives a sunny blue. By mixing rose madder and burnt sienna with it I can get beautiful blacks."

Carlson attacks his canvas with vigor, scraping it with palette knife, punching it with stiff brushes, glazing, scumbling and smearing—and swearing; finally stroking it tenderly, cajoling it into a well-behaved technical harmony.

John F. Carlson was born in Sweden in 1875. The list of prizes won during a long lifetime of painting in the United States and the record of museum acquisitions of his canvases fill a long column in *Who's Who in American Art*. Since 1925 he has been a member of the National Academy of Design. He belongs to many other art societies.

For many years he has given some of his time to teaching. Thousands of young artists have flocked to his classes at Woodstock, New York—Carlson's permanent residence—and to the Art Students League of New York. His book, *Principles of Landscape Painting** records the essential tenets of his teaching.

Carlson at 67 is still the Carlson of his earlier years. His personality has lost none of its vitality, nor his work its vigor. He has a friendly, out-giving nature that has endeared him to students and fellow artists. Carlson is an *institution* in the American art world.

*Bridgman Publishers, Inc.

DERELICTS — BY JOHN F. CARLSON

PEPPINO MANGRAVITE

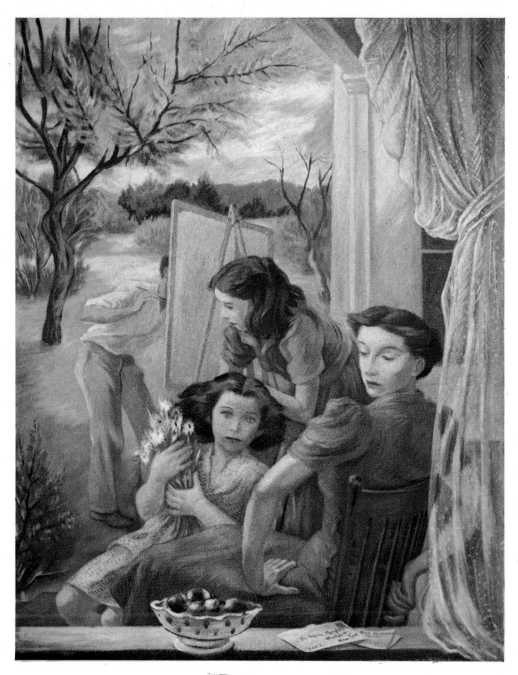

THE ARTIST'S FAMILY——BY PEPPINO MANGRAVITE

Courtesy Rehn Galleries

Peppino Mangravite

PEPPINO MANGRAVITE spends no longer than a single painting day on any of his canvases. But that final act, like an operatic performance when the curtain goes up on the opening night, has been preceded by innumerable rehearsals which have gradually brought the artist's conception to fruition and his facility to a point of confident mastery. Into the six or seven canvases which ultimately consume but as many days in their actual painting, Mangravite puts the creative energy and preparatory study of an entire year.

The purpose and methods of an artist are deeply mysterious to his fellow men who, by and large, think of him primarily as a craftsman, a fellow who has developed a great knack for delineating form and combining colors. If they credit him with genius it is a genius that flows from his hand rather than from his head. And too often they are right. For much of the world's art is nothing more than the reflection of life's superficial highlights which attract the painter's passing notice.

But the really great artist is a profound student searching for the underpainting of the human panorama. He sees and paints more than appears to the casual eye. What finally he sets down on canvas is something deeply felt and pondered as well as seen in the relationship of man to man and man to nature. It is something more than an incidental effect, it has a posi-

tive direction. This recalls an experience Mangravite had with Matisse, which he tells as follows:

"Having been invited to have luncheon with Matisse and a party of friends, I appeared at his studio at the appointed hour, entered unannounced and discovered that the French master was at work on a canvas, so wholly engrossed that he had not noticed my arrival. I waited quietly in the background until he laid down his brushes and discovered my presence. I urged him not to let me interrupt him, but he assured me that I had not. 'I had just finished,' he declared. His remark puzzled me because I had noticed that a small section of his canvas had no paint on it at all.

"Wanting to satisfy my curiosity, I kept trying to gather enough courage during luncheon to ask him why he had said his canvas was finished when a section of it was still untouched by his brush. Finally I did put the question to him. Matisse himself seemed puzzled by my question. He said he could not remember that any section of the canvas had not been covered with color and he kept thinking about his picture, trying to recall every detail of it.

"Upon returning to the studio he went at once to his picture, then turned to me smiling and said, 'Well, I had not noticed it, but it's perfectly all right. When I set myself to work I always start with a definite direc-

SUMMER VACATION —— OIL PAINTING BY PEPPINO MANGRAVITE
Rehn Galleries

Mangravite says he is interested in "the everlasting fugitive implications between men and women, in the subtleties of human relationships." He declares that he can get more tragedy, more of the lasting pathos of man, by painting him while he is smoking a cigarette, or taking a drink, but always in the company of the other sex. "All actual events are temporary — but only one thing is everlasting — what you capture of the moods of manhood"

Reproduction of the charcoal study for "Autumn" by Peppino Mangravite. From this study the lines of the drawing were transferred to the canvas as described in the text

tion in my mind. In the painting of this picture I followed a certain direction. As I developed the picture I suddenly discovered that I had completed my direction. Why go further?' "

An artist's direction is, as we have said, the result of his profound contemplation of life and of nature. But it is more than that. It is conditioned by what the man himself is. And that goes back to the day of his birth, even before.

The circumstances of one's birth and childhood are always important but with Mangravite they had more than the usual effect upon his life and his art. He was born on the tiny island of Lipari which lies a few miles off the northern coast of Sicily. Its name would scarcely be known to the world but for its use by Italy as a penal colony for her political prisoners.

On the closely guarded island of exile Peppino, the son of an Italian naval officer stationed on Lipari, spent many impressionable years in the strange environment of social ostracism, where his association with political outcasts profoundly influenced his thought and character. For these politicals though "dangerous" to the state were, naturally enough, men of intellect and imagination. His experience among them did much in shaping the background for his career. It gave the sensitive youth a serious outlook on life. The lad even received his first art training here, for one of the politicals, an artist, took the boy into his studio as an apprentice and taught him the beginnings of the painter's craft. His formal art education was continued on the Italian mainland and when only fourteen he was dissecting cadavers as part of his training in anatomy.

Upon his father's retirement from the Navy in 1912, the family moved to New York. But Peppino soon re-

turned to Europe to study and when still in his teens was studying in Paris. Back in New York in 1914 he painted by himself for six months, then became a student at Cooper Union. In 1917 he entered Robert Henri's class in the Art Students League.

So much for the early formative years. To give more than an outline of successive events in his career up to his recent successes would call for space not at our command. He was awarded a gold medal at the Sesquicentennial Exposition in Philadelphia (1926) for a mural painting. His first one-man show in New York was held in 1928. His second followed two years later and in subsequent years his exhibits traveled about the country to the principal museums where many of his pictures have remained in permanent collections; among them Phillips Memorial Gallery and the Corcoran Gallery in Washington; Whitney Museum in New York; Toledo Museum; Pennsylvania Academy of Fine Arts and Denver Museum of Art. Many of his canvases have gone into private collections.

In 1932 Mangravite was awarded a Guggenheim Foundation Fellowship which took him and his family to Europe. A second Guggenheim Fellowship in 1935 financed a year's painting in America.

But let us get back to Mangravite's Studio and see just how he goes about his work.

Although his pictures are actually painted during the summer in the barn studio of his country home in the Adirondacks, they have their beginnings months before in New York, the artist's winter residence. After he decides upon a picture motive, Mangravite mulls over the idea continuously and begins the study of its composition in a series of small pencil sketches. Then come innumerable drawings from nature and from models.

AUTUMN — OIL PAINTING BY PEPPINO MANGRAVITE
Rehn Galleries

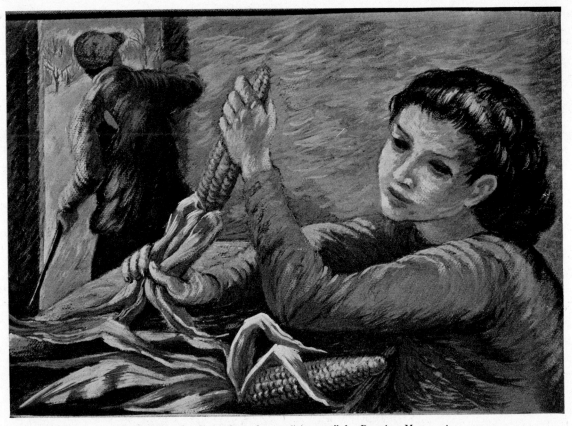

Preliminary Study in Gouache for "Autumn" by Peppino Mangravite
Significant changes in composition in the final painting include the treatment at
extreme left. Note how the tree, turned head of the hunter, and his upper arm
turn the interest back into the center of the canvas

A family is an incomparable asset to an artist for his models are always with him. Not only does he draw them incessantly, but their every mood, expression, action, constantly observed are automatically recorded upon his sensitized mind. So Mangravite's charming wife and his two daughters, Nina and Denise, are not only the artist's delight in a happy family relationship; they serve as models for many of his canvases, though they do not appear as portraits in his subject pictures.

"After the composition is organized," explains Mangravite, "I make a careful study for my picture in gouache. I do this with infinite care. Sometimes I work on it for a considerable time, at any rate until I feel it is what I want, for this gouache is my working study.

"The next step is a careful working drawing the exact size of the picture to be painted on the canvas. This I usually make on tracing paper with charcoal. From this charcoal drawing the outlines are transferred to the canvas which has been coated with an egg tempera ground of russet color. The transfer is made before this ground has completely dried. While it is in a semi-dry condition first a piece of thin cellophane is laid down upon it, then the drawing. The cellophane is to protect the back of the drawing from the soft ground. The transfer is made by gently going over the outlines with a stylus. This lifts off some of the ground and leaves a delicate tracery of the drawing on the canvas. Immediately after the transfer is made the highlights of the picture are brought out in advance by applying here and there over the russet color ground a mixture of cremnitz white and egg tempera emulsion. These white areas when painted over with oil have a tendency to 'shine through' the paint, thus adding an extraordinary luminosity to the picture. Over this preparation a thin solution of damar varnish is sprayed.

"Now when all this preliminary study and work has been done and I am ready to paint the final canvas, I mix up lumps of oil pigment to match the principal colors in the gouache painting, so I will not have to take time for this while I am painting. I put these pigments on a glass submerged in water to keep them fresh over night.

"The next morning I start early, perhaps at five-thirty or six o'clock. Before I start painting I am absolutely familiar with everything I want to do. I have all the things I shall need in the studio: the models walking around, my sketches, preliminary drawings from nature and the models, a careful, exact-size charcoal drawing and of course my gouache painting. The studio is a veritable 'arsenal'—Mrs. Mangravite has a more expressive word for it.

"After I start I keep going without interest in even the luncheon bell. The canvas must be finished before dusk that day. When daylight fades the picture is either a success or a failure. If a failure, it is destroyed and a fresh start has to be made another day on another canvas. Painting over a canvas after the pigment has dried simply destroys its freshness. I want my pictures to have

a wet look. Thus it is that I sometimes paint a subject several times before I feel satisfied."

Mangravite's work is not confined to easel pictures. He has executed murals for the Hempstead, Long Island, Postoffice and two twenty-foot-wide murals for the Atlantic City Postoffice. Then there was the mural painted for the Susquicentennial Exposition in Philadelphia—which we have already mentioned.

His method of procedure in his mural work is unusual; he begins his drawings on a large scale, laying-out the design the exact size of the wall space and working directly on large sheets of paper, without preliminary studies at small scale. He does this in the belief that full-scale attack gives results not attainable when the design begins small and is later blown up to fill the actual wall space. Areas which seem interesting enough in a small study are likely to be empty when greatly expanded, he declares. Not only that, the artist is likely to have a different feeling for the design when it is developed full-size.

Mangravite is an expert draftsman. His acquaintance with the human form is complete; he knows his anatomy. But while he could paint a perfect academic figure he never does. He distorts the figure to serve his objectives in expression and design. He usually elongates his figures and gives them diminutive feet. What he achieves by these devices only the student of his pictures can discover for himself. Perhaps he will be reminded of El Greco and Grüenwald who are Mangravite's masters. In his work the observant one may also see something of the influence of Delacroix, Goya, and Watteau, masters who have been a conscious influence.

It must be something of a triumph for Mangravite to have been honored by a one-man exhibition at the Art Institute of Chicago in 1941, at the time an important Goya Exhibition was being shown under the same roof.

Mangravite has very positive opinions upon the artist's place in society. The artist is to blame, he believes, for the weakness of his position in contemporary life. He still lives in his ivory tower and gives little heed to the needs of his fellows. Instead he calls them stupid because they do not understand him—and thus creates a gulf between artist and layman.

The world needs the artist who, if he directs his interest outward rather than inward, can contribute greatly to the richness of life. But he must change his entire point of view; think of himself as the giver of life—rather than a precious, specially privileged creature to whom the world owes both homage and a living. Not until he gets down among his fellows and tries to understand their spiritual needs can he hope to render that creative service which is his function in society.

Although Mangravite respects the artist as one of the most intellectual of men, possessing the greatest of potentialities, at the same time he considers him the most intolerant and at times the most obnoxious. "For one thing," he says, "there is a complete lack of professional ethics among artists. The average artist of average abil-

On the page opposite, reproduced at exact size, is a detail of the original charcoal working study for "Autumn" by Peppino Mangravite.

This is the last of a series of preparatory studies leading up to the final painting on canvas. From this drawing a transfer was made to the canvas. The marks of the stylus, used in making the transfer, show as light lines here and there

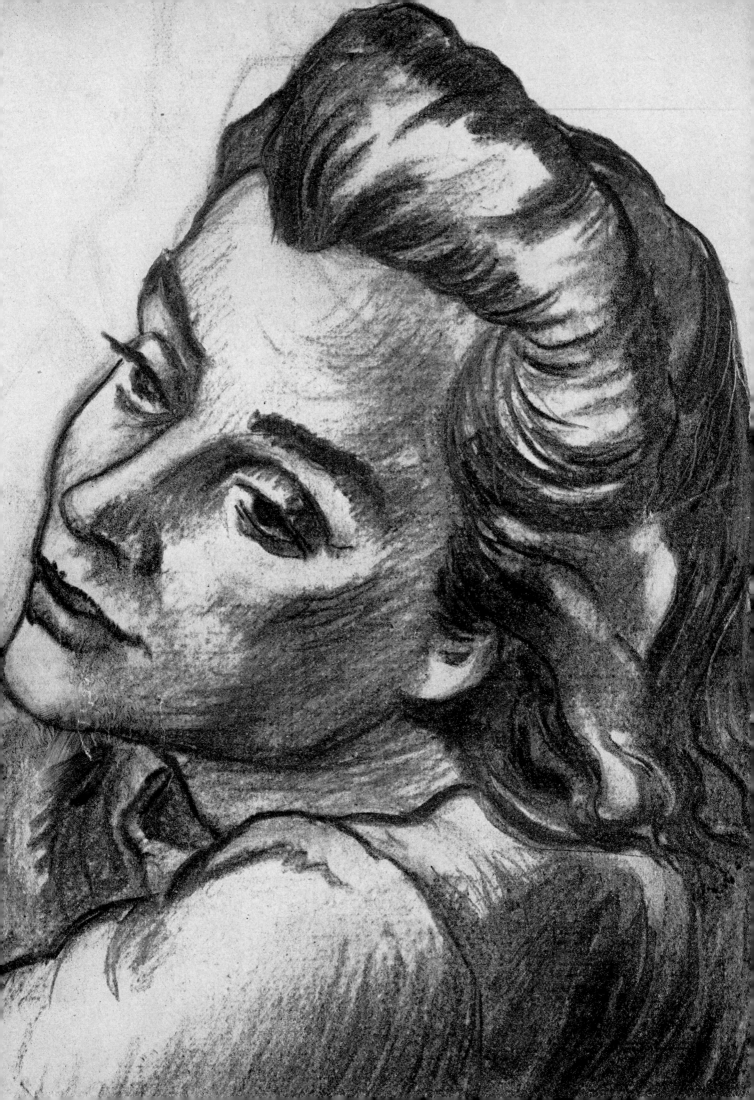

ity is supremely jealous and that takes the form of criticism of his contemporaries. Asked his opinion of the work of a fellow artist, he will not hesitate to pronounce it 'Lousy!' Imagine the effect of this on the layman! Where else in professional life can such lack of ethics be found? Did you ever hear a doctor criticize another member of his profession? If the doctor were as unethical as the artist the public would soon have as little confidence for the medical profession as much of it has for the painter's art. Before we can accomplish our desired ends, we need a change in spirit, and this change must come first from the artist and all those who are responsible for the moral and mental enlightenment of society. Indeed it will be such a change in the artist himself that will bring fullest freedom and widest scope to the growth and acceptance of the arts in this country."

It is fortunate that an artist of such practical idealism is interested in education and is willing to devote some of his time to students. In the winter he teaches painting at Cooper Union and the Art Students League in New York, and he has a class in mural painting at the Art Institute of Chicago. His influence is further extended through his lectures and his writings.

Mangravite has great personal force and charm. His love of life and his eager participation in it are at once felt in meeting him. Although primarily serious in temperament and intense in his reactions he has a delicious sense of humor which careful scrutiny of *The Artist's Family* (our color reproduction) will reveal; although greatly reduced from the original, the words "Bill Rendered" are faintly legible on the folded message in the foreground.

Peppino Mangravite is not the kind of artist who lives apart from the world—in an ivory tower. A passage in a letter received from him in the summer of 1942 reveals his humanism expressed in sympathetic and tangible form. He writes:

"It is curious that with all the perplexities confronting us these days I have been doing my best painting this summer. We are in our beloved Adirondack farm; feeling as guilty as hell that I am not doing enough for the war effort. But we are raising the winter's supply of vegetables and preserves for ourselves; and also driving our automobile for our neighbors who cannot afford a car. In the last three days I have driven to a funeral; to the hospital for two serious accidents; and to take a dying calf to the Vet—total 118 miles, which practically consumed my four-gallons-a-week supply of gas. If you knew my poor farmer neighbors you would love them too. Their miseries are unbound. Yet they never complain. God bless their souls. This summer, among other things, I have learned to get up at 5 A.M. I paint until noon—cultivate my garden in the afternoon; play some tennis—a plunge in the river; a supper of home-grown food—and sweet bed at 9 P.M."

THE ARTIST AND HIS MODELS
IN THEIR SUMMER HOME

1 *During the summer months the Mangravites live on their farm in the Adirondacks. The building in the foreground is the studio*

2 *Denise and Nina, 9 and 13, with their pony, Firefly*

3 *Mrs. Mangravite (Frances) and Denise sun themselves after a morning dip*

4 *This probably doesn't happen often. While not at work in his studio Mangravite is usually engaged with the manifold tasks supplied by even a vacation farm*

5 *The Mangravites fill a happy summer with many pleasant memories of picnics and frolics in the country*

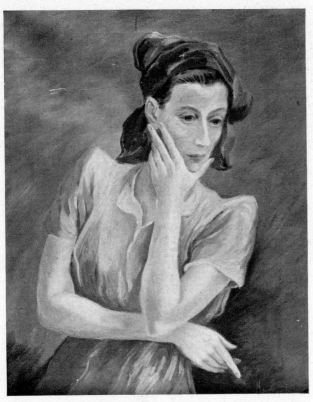

THE ACTRESS

TWO CANVASES BY

PEPPINO MANGRAVITE

DANCING
IN THE MOONLIGHT

American Purchase Prize

*Golden Gate
International Exposition
1939*

141